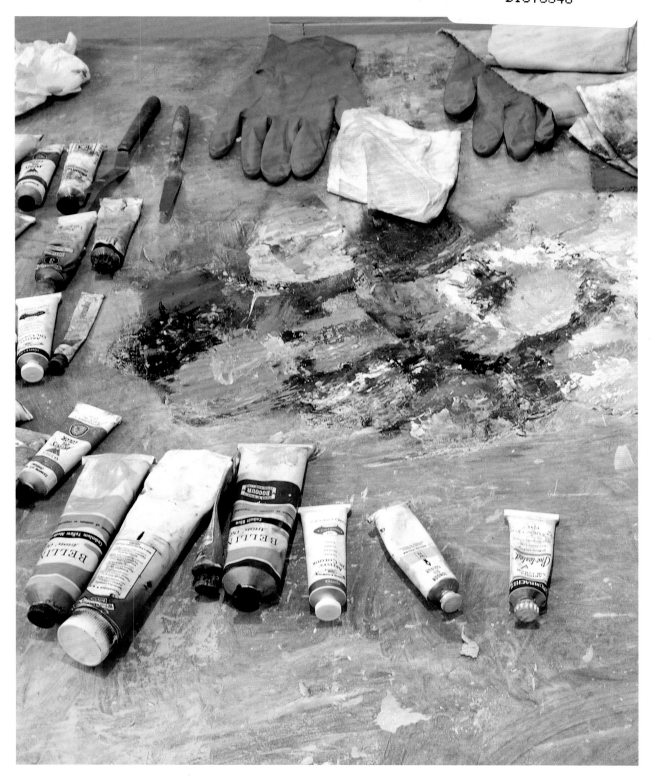

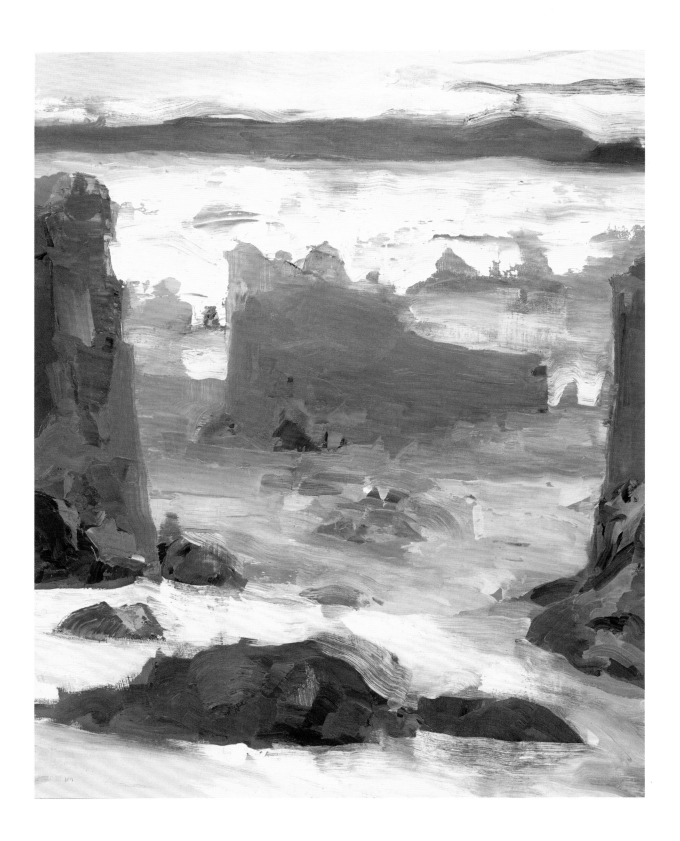

IMMANENCE AND REVELATION
The Art of Ben Frank Moss

With an essay by Joshua Chuang

Foreword and artist interview by Brian Kennedy

Contributions by Bruce Herman, Jeffrey Lewis, and Gregory Wolfe

Hood Museum of Art
Dartmouth College
Hanover, New Hampshire

Published by
Hood Museum of Art, Dartmouth College
Hanover, NH 03755
www.hoodmuseum.dartmouth.edu

Immanence and Revelation: The Art of Ben Frank Moss was published to coincide with an exhibition of the same title curated by Brian Kennedy and Barbara J. MacAdam and held at the Hood Museum of Art from September 13, 2008, through January 4, 2009.

This publication and its related exhibition were organized by the Hood Museum of Art and generously supported by a gift from Katherine D. and John H. Krehbiel III, Class of 1991, Thayer 1992; a grant from the George Frederick Jewett Foundation; a contribution from the Dean of the Faculty Office; and the museum's Ray Winfield Smith 1918 Fund and Eleanor Smith Fund.

Edited by Nils Nadeau

Designed by Glenn Suokko Inc.

All object photography is by Jeffrey Nintzel except for cat. 29, by James Via

Printing by Capital Offset Company Inc.

Front cover: *Landscape Sound No. 144*, 2002 (cat. 29)
Frontispiece: *Memory of HFM (Helen Figge Moss) No. 2*, 1991 (cat. 14)

Library of Congress Cataloging-in-Publication Data

Moss, Ben Frank, 1936–
Immanence and revelation : the art of Ben Frank Moss / with an essay
 by Joshua Chuang ; foreword and artist interview by Brian Kennedy ;
 contributions by Bruce Herman, Jeffrey Lewis, and Gregory Wolfe.
 p. cm.
"Published to coincide with an exhibition of the same title curated by
 Brian Kennedy and Barbara J. MacAdam and held at the Hood
 Museum of Art from September 13, 2008, through January 4,
 2009"–T.p. verso.
Includes bibliographical references.
ISBN 0-944722-35-0
1. Moss, Ben Frank, 1936—Exhibitions. I. Chuang, Joshua.
 II. Kennedy, Brian P. III. Hood Museum of Art. IV. Title.
 V. Title: Art of Ben Frank Moss.
N6537.M6686A4 2008
759.13—dc22

 2008034240

Contents

Preface and Acknowledgments

Brian Kennedy, Director
Hood Museum of Art

This exhibition and catalogue honor the multifaceted artistic talents of Ben Frank Moss, the George Frederick Jewett Professor of Studio Art at Dartmouth College. For the past twenty years, Moss has mentored countless Dartmouth students and made invaluable contributions to the College's studio art program. During the same time, he has pursued his own work with unrelenting passion and dedication, bringing to it his prodigious artistry and poetic sensibility. Featuring over seventy paintings, drawings, and prints, the exhibition includes a concentration of works in various media produced during his two decades at Dartmouth, as well as selected earlier paintings and drawings. The illustrated catalogue reproduces supplementary early works and presents a long-overdue scholarly examination of Moss's artistic achievements. *Immanence and Revelation: The Art of Ben Frank Moss* not only represents the most substantial exhibition and publication devoted to this under-recognized artist to date but inaugurates a planned series of Hood solo exhibitions and publications that will celebrate the work of Dartmouth's senior studio art faculty over the coming years.

It has been a distinct pleasure to become deeply acquainted with the work of Professor Moss. He is a painter of masterful technique, sincere conviction, and great determination. When considering a title for this project at Dartmouth College, I suggested *Immanence and Revelation* to evoke the artist's personal philosophy, preoccupation with theology, and belief in a Supreme Being and a heavenly paradise. His painterly world is void of humankind and has been for years; even buildings are rare in his work. The landscape, climate, and environment—a divine creation, in short—comprise this artist's world. Within it is worked out an endless array of tragedies, mysteries, and glories inherent and revealed by our human predicament. We do not know the answer to many of life's questions, but for those who wish to carry on with it, there must be hope. Ben Frank Moss's work is full of hope, embracing the natural world, scrutinizing, celebrating, reveling in it. Few painters achieve the level of consistency in quality of output that he has maintained for so many years. This only comes from adherence to the highest expectations of oneself. For Ben Frank Moss, it is all about standards, in artistic practice and in teaching. For those prepared to tolerate his demanding and high bar, the rewards have been great, as so many of his students attest. For those who recognize aesthetic quality in high degree, it is easy to acknowledge and honor his achievements.

This exhibition and catalogue could not have succeeded without the contributions of many individuals. First, we extend deep gratitude to Joshua Chuang, Dartmouth Class of 1998 and the Assistant Curator of Photographs at the Yale University Art Gallery, for his eloquent and perceptive catalogue essay "Call and Response: The Life and Work of Ben Frank Moss." As an art historian, artist, museum curator, and former Moss student, Chuang has brought a singularly well-informed perspective to the formidable task of summarizing Moss's artistic inspirations and achievements.

Thanks are also owed to three of Moss's colleagues for sharing their deep appreciation of his work: Bruce Herman, Lothlórien Distinguished Chair in the Fine Arts at Gordon College in Wenham, Massachusetts; Jeffrey Lewis, Professor of Art at Auburn University, Auburn, Alabama; and Gregory Wolfe, publisher and editor of *Image*, a quarterly journal, and director of the low-residency MFA in Creative Writing program at Seattle Pacific University. Each has known Moss at a different period of his career and written an insightful statement describing his distinctive artistic contributions.

Ben Moss's work is represented in the collections of numerous museums, including the Hood Museum of Art (cat. 52). We are pleased to feature in this exhibition loans from two additional institutions, the National Academy Museum in New York (cat. 14) and the Memorial Art Gallery of the University of Rochester (cat. 29). At the National Academy we are grateful for the support and assistance of Carmine Branagan, Director; Annette Blaugrund, former Director; Bruce Weber, Senior Curator of Nineteenth-Century Art; and Anna Martin, Registrar. At the Memorial Art Gallery, we acknowledge and thank Director Grant Holcomb, a longtime admirer of Moss's work who generously supported this exhibition from the outset; Marjorie Searl, Curator of American Art and Chief Curator; Susan Nurse, Visual Resources Coordinator; and Monica Simpson, Permanent Collection Registrar.

This project has been overseen in all its aspects by Barbara MacAdam, Jonathan L. Cohen Curator of American Art. Although we have been co-curators, she has applied herself to every detail to make a vital testament to Ben Moss's creativity through the exhibition and publication. As often before, I pay tribute to Bonnie's extraordinary capacity for work and her constant achievement of the highest standards of professionalism. The exhibition and catalogue benefited from the talents of additional Hood staff: Patrick Dunfey, Exhibitions Designer, designed the elegant installation; John Reynolds and Matt Zayatz, Lead Preparator and Preparator, assisted with the planning and implementation of the installation; Lesley Wellman, Curator of Education, served as the education depart-ment's liaison for the exhibition; Kellen Haak, Collections Manager/Registrar, supervised the logistics surrounding loans from the artist and museum collections; Kathleen O'Malley, Associate Registrar, facilitated the catalogue photography; Sharon Reed, Public Relations Coordinator, publicized the exhibition to the regional and national press; Nils Nadeau, Communications and Publications Manager, edited the catalogue manuscript with his usual care; Karen Miller, Exhibitions and Events Coordinator, assisted with the organization of public programming; Juliette Bianco, Assistant Director, and Nancy McLain, Business Manager, oversaw the exhibition finances; Christine MacDonald, Business Assistant, provided critical organizational support; Sharon Greene, Development Officer, prepared the museum's successful application to the George Frederick Jewett Foundation; and Katherine Hart, Associate Director and Barbara C. and Harvey P. Hood Curator of Academic Programming, contributed important counsel throughout the planning and delivery of the project.

The catalogue's handsome appearance is due to the talents of two local professionals who have regularly contributed to the museum's publications: Jeffrey Nintzel, who skillfully provided nearly all of the photography for the volume, and Glenn Suokko, who crafted the book's elegant design and ushered it through production. We also extend thanks to Jay Stewart and his talented staff at Capital Offset Company—especially John Maltzie—for their extraordinary efforts in achieving the best possible color reproductions of Moss's works.

We are deeply grateful to Katherine D. "Kate" and John H. "Yaz" Krehbiel, Class of 1991, Thayer 1992, for their magnanimous donation in support of this catalogue. A former Moss student and talented painter in his own right, Yaz Krehbiel's generous dedication to the success of this endeavor is an extraordinary tribute to his mentor's abiding influence as a teacher. The George Frederick Jewett Foundation made a major donation toward the exhibition. It is with great sadness that we note the recent passing of George Frederick Jewett (1927–2008), Dartmouth Class of 1950, a leading San Francisco philanthropist who has been one of Moss's most generous patrons. Ben Frank Moss has held the

George Frederick Jewett professorship of studio art at Dartmouth College since 1993. Dartmouth's Dean of the Faculty's office also contributed generously to this project. We give special thanks to Carol Folt, Dean of the Faculty, and Katharine Conley, Associate Dean for the Arts and Humanities, for directing funds toward the Hood's recognition of this talented Dartmouth professor, who recently announced his retirement. The Hood Museum of Art is fortunate to maintain several designated exhibition endowments that sustain the institution's programming from year to year. For this exhibition and catalogue, the museum benefited from the support of the Ray Winfield Smith 1918 Fund and the Eleanor Smith Fund. We also extend our sincere gratitude to Christopher and Sally Shove Lutz Adv'90 for working with us on an aquisition of Ben Moss's work for the Hood Museum of Art collections.

Finally, we owe warm thanks to Jean Moss for her keen review of the manuscript, and especially to Ben Frank Moss for his cooperative and timely assistance with every aspect of this exhibition. His eloquent insights, offered in countless conversations and in the interviews published in this catalogue, have enhanced our appreciation of his artistic development and the beliefs and attitudes that form and underpin his artistic vision. Gaining a deeper knowledge of both the artist and his work has been personally enriching, and I am delighted to have the opportunity through this exhibition and publication to engage our audiences with the richly layered artistic achievement of Ben Frank Moss.

Call and Response:
The Life and Work of Ben Frank Moss

Joshua Chuang

There are moments in our lives, there are moments in a day, when we seem to see beyond the usual. Such are the moments of our greatest happiness. Such are the moments of our greatest wisdom. If one could recall his vision by some sort of sign. It was in this hope that the arts were invented. Sign-posts on the way to what may be.

Robert Henri, *The Art Spirit*

To behold the work of Ben Frank Moss is to encounter a fiercely personal approach to the visual life—one taken up in response to the call of private revelation rather than for popular acclaim. For this reason, the paintings, drawings, and collages Moss has steadfastly produced during his career as an artist cannot be traced conveniently within the general narrative of art history over the past forty years. His distinctive efforts to find form for the ineffable are not hidebound by any particular school or ideology; they are rooted instead in a more fundamental pursuit shared by a long and diverse genealogy of artists, poets, and composers: "a longing to be held, captivated by a spiritual force—something unseen but sensed."[1]

Robert Henri once remarked that "for an artist to be interesting to us, he must be interesting to himself," a notion to which Moss has duly subscribed.[2] Although he engages in the vocabulary of abstraction, his compositions originate in specific memory and concrete experience. Like his contemporary Howard Hodgkin, Moss might accurately describe his own work as "representational pictures of emotional situations." He is fond of relating anecdotes from a life keenly observed, citing them as evidence that enduring truths can come from the most unexpected sources. One such story involves his wife Jean's first-time encounter with a precocious seven-year-old neighbor who proceeded to introduce herself unprompted and show a rock she had been using to chip away at another rock. Curious, Jean inquired if she planned to shape the rock into an arrowhead, to which the young girl replied: "No, I let the rocks decide what they should be."

The story seems an apt metaphor for the way Moss has carried out his own life and work. At the core of his evolving practice lies a fervent regard for the mystery of creation. He is careful not to rely too heavily on his obvious facility for drawing, opting to approach each blank surface without preconception and with the anticipation of unexpected adventure. To this end he has produced compositions that lay bare the process of their making. Scrutiny of their richly textured surfaces may reveal evidence of entire areas erased or scraped away and then reworked, but seldom does a finished piece feel belabored. For Moss, art-making is an endeavor that requires the courage to hold still enough to reflect on life's vicissitudes and the willingness to work on the edge of failure. Because of this, whether endowed with the deep, lush tones of charcoal or the luminous hues and sensuous texture of oil paint, his art carries the layered history of a palimpsest and the distilled intensity of personal revelation. His most successful pieces exhibit the startling immediacy of a "held dream . . . a poetic gateway to an inner experience."[3]

Benjamin Frank Moss III was born in Philadelphia in 1936 to a Presbyterian minister and the daughter of a prominent St. Louis banker. Though the effects of the Great Depression reverberated throughout the Philadelphia area, Moss recalls having been largely shielded from the chaos that surrounded him. In 1938, the Moss family settled in nearby Devon, where his father took up the pastorate at St. John's Presbyterian Church.

Later that year, Moss's maternal grandparents, their fortune and prospects decimated, fled St. Louis and moved into the Mosses' manse for what they politely referred to as a prolonged "vacation." Moss and his sister Lois remained blissfully unaware of their grandparents' situation and remember their presence with fondness. While Moss's mother and doting grandparents raised the children, his father ventured outside of their sheltered household to minister to the church's many congregants. In the best sense, Moss recalls his father as having been "married to the church," demonstrating a selfless dedication to community-building and serving those in need.

At the end of World War II, the Mosses left Devon for Huntington, New York, which at the time was still a quaint village on the north shore of Long Island. Now a young boy, Moss became an avid explorer and an agile climber of trees. "The trees, without fail, seemed to extend a welcome. I approached them with respect and the anticipation of being transformed."[4] Held aloft in a tree's branches, Moss was able to let his imagination expand and see the world anew. His extended exposure to the natural landscape of rural Long Island also attuned him to its shapes, textures, and colors, especially the deep, radiant blue of the sound. Midway through his sophomore year at Houghton College, he enrolled on a whim in a studio art course. "I knew immediately without any doubt that I had been claimed," he recalls. "Something in me expanded, turned toward a forgotten time, turned toward a memory. It was a complete conversion."[5]

In the mid-1950s, his parents left Huntington and moved west to Denver, Colorado, where Moss first experienced deep space and the grandeur of the mountains. In 1955 he transferred to Whitworth College, a small Presbyterian school in Spokane, Washington, where he became enthralled by the dramatic landscape and shifting atmosphere of the Pacific Northwest, as well as by Jean Marilyn Russel, the woman he would later marry. At Whitworth, Moss continued his education as an artist, taking classes with the painter Herman Keys. Keys had studied at New York's Art Students League with George Grosz and Reginald Marsh, and the social realist tradition he inherited resonated with Moss's own quest to bind his religious convictions

with his creative endeavors. Keys introduced Moss to the work of his own mentors, as well as to that of Rembrandt, Van Gogh, Rouault, and Grünewald, and made it clear that art was to be thought of as a serious profession that demanded utter devotion and complete

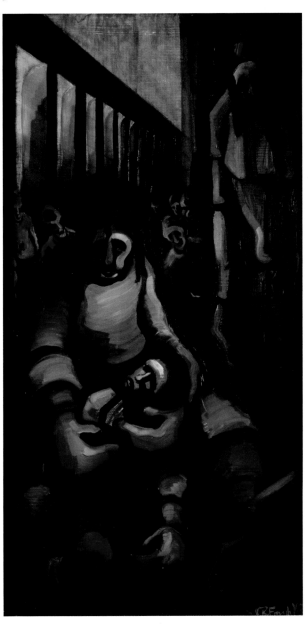

FIG. 1.1

Ben Frank Moss, *Mother and Dying Child*, 1959, oil on Masonite, 48 x 24 inches. Collection of the artist.

attention. Adopting his teacher's emphasis on narrative and his belief that an artist was obliged to address the human condition, Moss moved from making delicate still lifes to dark, brooding paintings that portrayed human suffering (fig. 1.1). During this time, Moss also became deeply affected by his readings, which included a biography of Toyohiko Kagawa, a Japanese Christian activist who decried the pernicious materialism and violence of modern society, and Leo Tolstoy's *My Confession, My Religion*, and *The Gospel in Brief*, which provided compelling arguments for pacifism.

As he concluded his undergraduate studies, however, Moss had not resolved the question of whether his art served any real purpose. With so much suffering in the world, how could he justify his efforts as a painter? Could art actually impact the lives of those in need? To test his true calling, Moss enrolled at the Princeton Theological Seminary, the pull to follow in his father's footsteps still strong. Within a few months, it became clear that he could not live without painting. He withdrew from the program after one year, but not before being reminded of a critical truth. Pulled aside by a professor after having submitted a paper about the inescapable reality of death, Moss was told, as if from on high: "Yes Ben, there is death. But there is also *life*."

Soon after that exchange, Moss began to view art as "a means of objectifying a personal truth," a viable way of expressing his spiritual life in all its dimensions.[6] In 1961, he entered the MFA program in painting at Boston University, where he met Walter Murch, who had joined the school's faculty that year. Unlike many of his colleagues who held narrow definitions of the kind of art worth following, Murch recognized greatness in a variety of things. During the first lecture of the semester, Moss recalls his teacher projecting slides of a surprisingly diverse selection of paintings he considered exemplary. "*That's* a painting," Murch uttered with each new slide, suggesting that there was no single way to arrive at the beautiful or meaningful in art. Murch helped Moss understand that "there was painting that was like journalism, reporting the facts, and there was painting that was like poetry, carrying one beyond fact to possibility."[7] Where Herman Keys had steered his students toward a specific aesthetic approach, Murch sought to cultivate his students' unique, independent

visions. His belief in their ability to make transcendent art out of their own life experiences impelled Moss to seek a more allusive approach to his art.

In 1962, Moss attended a retrospective of the California painter David Park at Boston's Institute of Contemporary Art and became taken with the way Park managed to attend to figurative subject matter while remaining engaged with the challenges of painterly abstraction, especially his luscious application of paint and use of a high-contrast palette. Through Park's work, Moss discovered the work of fellow Bay Area artist Richard Diebenkorn and immediately set about working through these influences in his studio. On large canvases, Moss painted a series of airy, modern interiors inhabited by seated figures and tables topped with everyday objects (figs. 1.2, 1.3). Edges and surfaces

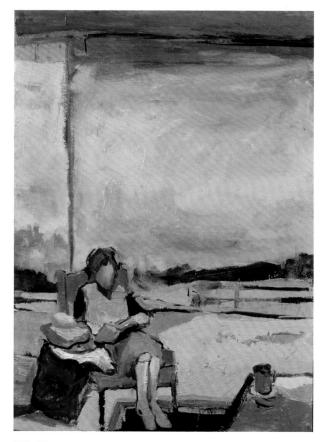

FIG. 1.2

Ben Frank Moss, *Seated Girl (Yellow Green Hat)*, 1963, oil on canvas, 42 x 29 inches. Collection of the artist.

FIG. 1.3

Ben Frank Moss, *Interior (TUP)*, 1963, oil on canvas,
42 x 34 inches. Collection of the artist.

cupied chair standing alone in the landscape [fig. 1.4]. This proved puzzling, but I accepted the tension between the chair and the open landscape, trusting that in time it would explain itself. Concurrent with this shift in the painting was the nagging memory of the community of painters I had left in Boston. I could fill my studio with the sound of Bach or other music I loved, but there was nevertheless an abiding silence that produced a longing in me. There was no dialogue with other artists. I was *alone*.[8]

To supplement his wife's income as a nurse, Moss began teaching local undergraduate art courses at Gonzaga University and Fort Wright College. In the studio, he began to transition from the large scale and high-contrast palette that had characterized his Boston years, embarking on a series of modestly sized, nearly monochromatic works on paper. Among this new body of work was a series of abstract drawings with collage elements (cats. 48, 49) that recall the

reflect crisp light—articulated with angular, brushy blocks of high-key colors—emanating from large windows or open doorways that reveal a view to a verdant landscape beyond.

After graduating from Boston University, Moss elected not to follow his classmates to the bustling artistic communities of New York City or San Francisco but to return to the familiar but remote environs of Spokane, where he could more ably afford the time and space to forge his own path. No longer a student, he used his newfound independence to experiment with the potential of freer brushwork and an earthier, more subdued palette. Moss recounts his experience from this period:

As I launched the new work in Spokane, I noticed right away that I was having trouble finding the focus of the earlier paintings. The figure was now playing a secondary role, and then it disappeared altogether, replaced by an unoc-

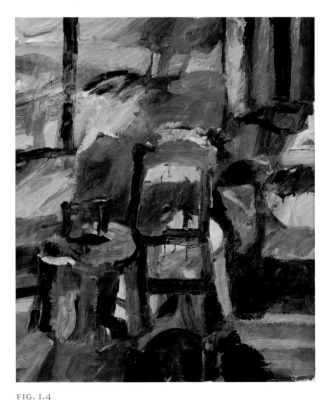

FIG. 1.4

Ben Frank Moss, *Chair Interior No.2*, 1965, oil on canvas,
48 x 38 inches. Collection of the artist.

controlled chaos and loose spontaneity of works on paper by David Smith and Willem de Kooning, and a concurrent group of charcoal and turpentine drawings (cats. 50, 51) with elemental, skittery marks that crackle with the hushed intensity of a distant storm. These new works signaled a fresh start in their inchoateness, a wringing out of the strong influences Moss had absorbed over the years.

In the late 1960s, Moss revisited the subject of the figure with a series of small drawings executed in graphite and ink depicting generalized figures jumping into or emerging from holes in the ground. No doubt informed by nightly reports of the death toll from the war in Vietnam, these surreal scenes also triggered Moss's own apprehensive experience of having to appear before a military draft board a decade earlier. Over the next few years, on large sheets of paper embedded with tempered lead white paint, Moss conceived a haunting series of torsos—naked, drained of color, lacking heads as well as extremities—standing or moving methodically through hazy, nebulous spaces (figs. 1.5, 1.6). Their enigmatic presence seemed to evoke the otherworldliness with which his mentor Murch endowed ordinary objects in his paintings (fig. 1.7), while their fleeting movements, rendered faintly in pentimenti, recalled those frozen in Eadweard Muybridge's nineteenth-century motion studies. Utterly isolated, the figures appear lost in a fog, echoing the futility of a war being waged half a world away.

Gradually, as more artists and art students relocated to Spokane to work and study, Moss, having thrived under the guidance of generous mentors as well as from his experiences at Yaddo, the upstate New York artist community, joined a few of his Fort Wright colleagues in envisioning an ideal artistic community of their own. In 1972, with a group of students, they renovated an abandoned building in downtown Spokane and founded the Spokane Studio School, with Moss serving as the school's dean. Modeled after the New York Studio School, the Spokane Studio School sought to provide an alternative to the fragmented, course-based curriculum that prevailed in colleges and universities, taking a more immersive, apprenticeship-based approach to training young artists. All who took part in the school sacrificed greatly to do so:

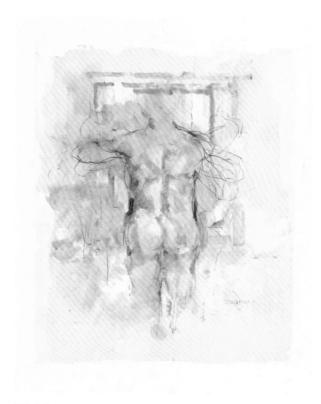

FIG. 1.5

Ben Frank Moss, *Standing Figure "C,"* 1969, oil and graphite on paper, 26 x 19⅛ inches. Collection of the artist.

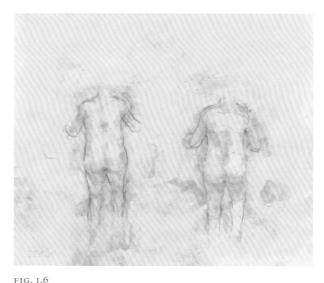

FIG. 1.6

Ben Frank Moss, *Two Figures No. 4*, 1969, oil and graphite on paper, 7¼ x 7¹/₁₆ inches. Collection of the artist.

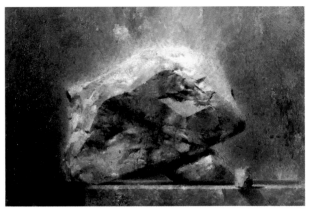

FIG. I.7

Walter Murch (American, 1907–1967), *Moon Rock*, 1961, oil on canvas, 21¾ x 32 inches. Whitney Museum of American Art, New York; Gift of the Ford Foundation Purchase Program; 62.12.

none of the faculty took a salary, and since the school was not accredited, the students, who each paid nominal tuition in order to support and maintain the facility, did not receive degrees. Although the school folded after three years, the sense of community it managed to establish was profound.

The same year he cofounded the Spokane Studio School, Moss had another formative experience. During a visit to the Pasadena Art Museum (now the Norton Simon Museum), he became mesmerized by an exhibition of Appalachian and Native American folk art. While the objects Moss recalls—cornhusk dolls, red clay pots, handwoven baskets—were small and utilitarian in nature, they were so beautiful and lovingly made to his eyes that they blurred the distinction between high and low art. Following the exhibition, he visited the museum's collection of modernist paintings, which unexpectedly failed to spark his imagination—until he came to one of the smallest works on view, a collage by Kurt Schwitters composed of cast-away scraps of paper and fabric (fig. 1.8). Despite its diminutive size, it possessed an intimate and condensed beauty that offered a compelling alternative to the heroic, demonstrative scale of the painting of the time.

Soon thereafter, Moss returned to still life as a subject, producing a steady flow of charcoal drawings that took household objects as nominal subjects to work out formal issues of shape, light, and shadow and larger metaphysical issues of presence and absence. He worked from memory rather than direct observation, treating sheets of paper as private arenas in which he could experiment and explore without a fixed agenda. Recalling restless compositional revisions of Alberto Giacometti's work, Moss's drawings from this period manage to extract a spiritual substance from the most prosaic physical forms and suggest an extended passage of time. Lines and tones have been repeatedly erased and redrawn in different arrangements, all in search of an elusive and previously undiscovered equilibrium. Fellow artist Susan Mareneck wrote about the evanescent nature of these domestic tableaux (fig. 1.9): "We get a glimpse of order, of the coherence of objects in

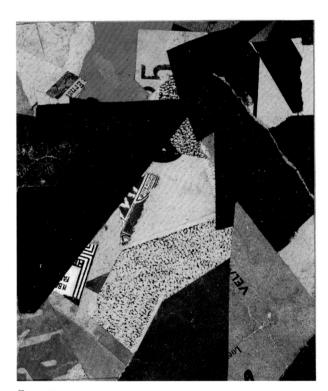

FIG. I.8

Kurt Schwitters (German, 1887–1948), *Mz 457*, 1921, collage with pasted paper and cloth on textured wove paper, composition 7⅛ x 5¾ inches; sheet 8¾ x 7¼ inches. Norton Simon Museum, The Blue Four Galka Scheyer Collection; P.1953.562. © 2008 Artists Rights Society (ARS), New York / VG Bild-Kunst, Bonn.

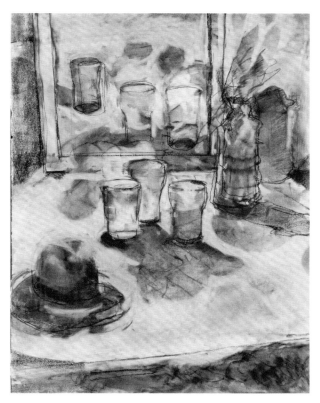

S.L. No. 143 Hat and Objects on a Table, 1978, charcoal on paper, 25 x 19¼ inches. Collection of the artist.

space. The invitation is made, but before we can accept, it is taken away."[9]

Clearly inspired by the bold formal play of Cézanne's canvases as well as the meditative calm and pared-down palette of Giorgio Morandi's still lifes, Moss continued to develop the elusive character of his work with a series of small oil paintings on paper. As with the drawings, the objects he chose to depict—everyday forms such as vegetables, goldfish bowls, and boxes—were not the true focus of the paintings as much as they were vehicles to address matters of luminosity, materiality, and, most notably, color, which he had not substantially engaged with in over a decade. In their subject and generosity of surface, paintings such as *Eight Shallow Dishes* (cat. 3) share an affinity with those of Wayne Thiebaud, but they eschew Thiebaud's electric palette, hard shadows, and intensity of subject. Instead, Moss's work from this period features more

subdued hues of pale rose, pistachio green, and blue-grey, punctuated by impressionistic dabs and strokes of Matissean yellow and orange-red that add a playful tang. In *Vegetables in Two Bowls* and *Box Color Impressions* (cats. 2, 1), forms seem to disintegrate rather than coalesce, melting into each other rather than allowing the viewer to experience them as whole. In their reengagement with the expressive potential of color and their rich interplay of forms, these works represented for Moss the beginnings of a distinct, mature style.

In 1975, after closing the Spokane Studio School, the Mosses moved to Iowa City, Iowa, where Jean enrolled in a graduate program for nursing and Moss accepted a teaching position at the University of Iowa. Despite the charms of the Midwestern landscape and the opportunity to return each summer to Valley, Washington, where he and Jean built a home and studio by hand, Moss felt an implacable longing for the natural settings that had molded his impression of the world during his youth. In the studio, he shifted from rendering still lifes to addressing, for the first time, the subject of the landscape. Reflecting upon the forests, open fields, and crystal blue waters of his native Long Island and the silver light and vast space of his beloved Spokane, Moss continued to refine his palette and brushwork, greatly enlarging the format of his compositions to evoke his own lush memories of these settings. Like the American luminists Frederic Edwin

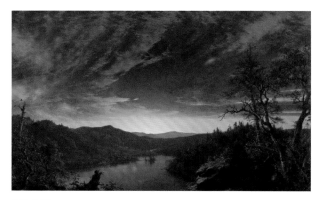

Frederic Edwin Church (American, 1826–1900), *Twilight in the Wilderness*, 1860, oil on canvas, 40 x 64 inches.
© The Cleveland Museum of Art; Mr. and Mrs. William H. Marlatt Fund; 1965.233.

Church (fig. 1.10) and Sanford Robinson Gifford more than a century earlier, Moss felt at liberty to introduce a certain degree of invention into his compositions, elevating his viewpoint to emphasize the sublime in his imagined vistas. His use of impasto and thick, fluid brushstrokes suggest a debt to the impressionists and their belief in the ability of paint to convey the essence of a subject. A more revealing comparison might be drawn, however, with Piet Mondrian's luminist landscapes of 1908 to 1910, when he broke with centuries of Dutch landscape tradition to explore a more daringly abstract, expressionistic style. Using only three primary hues—blue, yellow, and red—his composition *By the Sea* (fig. 1.11) renders the scene at the apex of its sublimity, reflecting the artist's conviction in art's capacity to provide spiritual clarity to both maker and viewer.

Moss's landscapes from the early 1980s to 1991 offer a vision for a new American luminism suffused with the quiet atmospheric colors and subdued light of the Pacific Northwest. As in the work of his luminist forebears, they offer the affirming pleasure of the grand vista, but the gestural physicality of Moss's brushwork also draws certain distant details to the surface. Hov-

ering at the edge of abstraction, the land masses that anchor *HFM (Helen Figge Moss) Memory* and *Island Dream No. 4* (cats. 7, 12) at once seem miles away and close enough to touch. In *Columbia Summer* and *Columbia Dream* (cats. 16, 18), the ground plane tilts radically upward toward the picture plane, as it does in classical Chinese painting, presenting an impossibly clear view of the cool, azure-blue river that winds its way upward into the distance through vertiginous rock formations. The clouds are particularly expressive: in *Columbia Winter* (cat. 17), they appear as steely, smoke-like plumes, like those that animate John Constable's landscapes; in *Warmth of Light* (cat. 8), they burn with the heightened climax of a Caspar David Friedrich sunset. In Moss's masterful depictions of water and sky—the two most expansive elements of the natural landscape—the viewer is transported beyond a precise physical setting to a sprawling inner landscape of pure emotion.

A number of these landscapes were exhibited in Dartmouth College's Jaffe-Friede and Strauss Galleries in 1989, the same year that Moss accepted an appointment to chair the school's Department of Studio Art. With the natural splendor of New Hampshire's Upper Valley region reminiscent of rural Long Island and Pennsylvania, the move east, according to Moss, felt like a homecoming. Over the next two decades, as his mentors Herman Keys and Walter Murch had done for Whitworth College and Boston University, respectively, Moss would inject Dartmouth's program with a new sense of rigor, expanding the number and range of class offerings and raising the level and seriousness of the work being produced. And he found, in turn, that interacting with the school's talented and highly motivated student body reinvigorated him and his work with possibility.

In 1992, Moss abruptly stopped painting large, lyrical landscapes after receiving the tragic news that their Washington neighbor's daughter and two young children had inexplicably been shot by her husband before he turned his gun on himself. Thinking of this beloved family, Moss recalled "how quiet and still the countryside was for days. As I worked in the studio, there wasn't a day nor hour that I didn't think—dwell on the horror of what had happened. It was like acid eating at

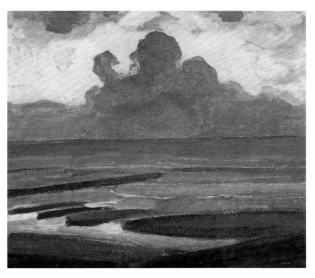

FIG. 1.11

Piet Mondrian (Dutch, 1872–1944), *By the Sea*, 1909, oil on cardboard, 15¾ x 18 inches. Yale University Art Gallery; Gift of Bruce B. Dayton, B.A. 1940; 1972.93. © Mondrian/Holtzman Trust c/o HCR International, Warrenton, VA.

the edge of my brain."[10] These deaths reopened Moss's wounded memory of a dear friend who had committed suicide decades earlier. Not long before the friend ended his own life, Moss and his wife had taken him sailing in the Long Island Sound. They were still far from shore when night fell and the winds picked up; Moss recalls "the sails snapping in the wind, the ropes straining," and his own feelings of foreboding as the three made their way back to Long Island.[11]

These devastating losses shook Moss to the core and caused him to reexamine the pillars of his life. As he looked inward for answers, his drawings and paintings became charged with a potent sense of immediacy. In the drawings, Moss traded the deliberate indeterminacy of the earlier still life drawings for bold, rapturous strokes of charcoal that sweep urgently across the frame. While titles and visual details such as *Night Sail / Storm No. 1*'s mast and triangular sail forms (cat. 53) allude to Moss's recollections of that fateful evening, the level of abstraction and force of the mark-making call to mind a greater, enveloping darkness. As if enacting a scene from Dante's *Inferno*, these drawings thrust the viewer dynamically into the eye of a fiery storm, their only respite being found in their flickering pockets of light.

His paintings from this period also convey a greater intensity. Reverting to the small picture, Moss used brushes of varying widths as well as palette knives, alternately spreading, brushing, and wiping away paint to create complex interactions of colors and textures. Braided through these works is a visual motif found in certain of de Kooning's paintings—the thick, dark, gestural strokes that serve to both agitate and stabilize the compositions. Exuberant high-key colors such as cadmium yellow resurface, but in these paintings they are juxtaposed, sometimes wildly, with granite pinks, crimson reds, emerald greens, and aquamarine blues in a manner that seems to owe more to the Fauves than to Diebenkorn. Here, color has been liberated from form; the hue and texture of the paint instead assume the role of form while connoting a universal meaning. Unlike the blazes that swirl violently across the nautical drawings, those conjured in lustrous works such as *Ascension Fire No. 4* and *No. 6* (cats. 22, 23) do not inspire feelings of immanent peril but rather refine-

ment and assured renewal. The incandescent glow emanating from the center of *Garden Gateway No. 6* (cat. 25) bears an uncanny resemblance to sunlight passing through stained glass. Moss has endowed these compositions with incredible richness by thinning his paint to varying viscosities. At its thinnest, it leaves the striated trace of dry bristles; at its most luscious, it resembles the buttery frosting of a cake. The impasto is in fact so pronounced at times that the surfaces seem to be sculpted rather than painted. At once dense and spacious in their inward dimension, they pulsate with the concentrated sense of beauty and reclamation that Moss had found in Kurt Schwitters's Merz collage two decades earlier. These elegiac works show Moss at the height of his powers, transfiguring memories of death and tragedy into revelatory worlds of light and life.

In his most recent bodies of work, Moss demonstrates a sure, virtuosic hand. Extending the motif of the landscape, these works no longer refer to a specific region or event. They seem instead to synthesize the totality of the artist's physical, spiritual, and emotional experience, culminating in a fresh, individualized vision of a glorious world beyond. Even further reduced in scale, the paintings and drawings exude a new confidence that manifests itself in a greater economy of means. Some in fact only register as landscapes because of a single thin line or a difference in value that stretches from edge to edge and suggests a horizon. On the whole, they more liberally embrace spontaneity, allowing the materials to speak eloquently on their own terms. One of the more striking feats of the ink drawings from the series *Landscape Sound* (cats. 59–64), for instance, is their harnessing of the white of the paper to convey a wholly believable sense of light. As in seventeenth-century Dutch landscapes, the upper two-thirds of a given composition is devoted to the sky, where calligraphic splatters, splotches, and variegated washes of tone evoke anything from a hazy summer day to the onset of a sudden squall.

The paintings from the series *Landscape Reflection* (cats. 30–47) exhibit a similarly abbreviated style. Paint is applied wet-on-wet and boldly smeared, streaked, and scraped across the surface of stiff paper to suggest the delineation of sky and land—or, more precisely, sky and sea, as Michael Stone-Richards has observed.

The finish is more raw than refined, brushstrokes are obscured with thick, fluid applications of paint, and the most ravishing colors are used sparingly. Uneven edges and residual daubs of paint seem to take on a particular significance, registering as the lining of a cloud, an outcropping of rock, or the brilliant reflection of light on the water's surface. As Mondrian did in his early landscapes, Moss has reduced the palette for each work to three or four main hues. With unalloyed pleasure, he has coaxed some of the most unexpected combinations of colors, drawn from an increasingly sophisticated and mature range, to coexist in a durable harmony.

Despite their intimate scale, these works manage to imply a much larger and unbounded environment, accomplishing the inverse of de Kooning's stated aspiration for his own work: to make "a big painting . . . look small."[12] The seeming simplicity of their execution is in fact hardwon; success is infrequent, and some of the works might only have been redeemed by an unlikely interaction of color or a fortuitous movement of paint. Moss has carried this intuitive sense of improvisation to his latest pieces, which seem to circle poetically back to past wellsprings of inspiration. Sail-forms reappear as a leitmotif in the new collages, whose purposefully unrefined technique recalls those made in Spokane over four decades earlier, and whose lyrical resourcefulness echoes that of a Schwitters collage. The title of the series, *Cardinal North*, refers to a point on a compass. Fittingly, they are named not after a place but a direction toward a known destination. Although the exact route has remained an abiding mystery, signposts of revelation have lit the way. "A man's work," claimed Albert Camus, "is nothing but this slow trek to rediscover, through the detours of art, those two or three great and simple images in whose presence his heart first opened."[13] The quote hangs prominently in Ben Frank Moss's studio, a poetic summation of his ongoing efforts to reach the invisible, transcendent world beyond.

Notes

1. Ben Frank Moss, "Begging to be Blessed," lecture delivered at Dartmouth College, April 1994.
2. Robert Henri, *The Art Spirit*, 3rd ed. (New York: Basic Books, 2007), p. 13. Originally published by J. B. Lippincott Company, 1923.
3. Ben Frank Moss, "Turning toward the Light," lecture delivered at Northwestern University, 1997.
4. Ben Frank Moss, "Looking for Likeness," lecture delivered at Vassar College, 1979.
5. Moss, "Turning toward the Light."
6. Ben Frank Moss, "Turning toward the Light," in *Whitworth Today*, Spring 2006, p. 30.
7. Moss, "Turning toward the Light."
8. Ben Frank Moss, "The Empty Chair," in *Image* 38 (Spring 2003), p. 46.
9. Susan Mareneck, "Ben Frank Moss, Painter," *Kansas Quarterly* 14 (Fall 1982), p. 46.
10. Ben Frank Moss, untitled lecture given at Messiah College, October 1995.
11. Claire Rossini, "Inevitable Transformations: Recent Work by Ben Frank Moss," in *Ben Frank Moss: A Vision of Passage* (Hanover, N.H.: Dartmouth College, 1994), p. 5.
12. Mark Stevens and Annalyn Swan, *De Kooning: An American Master* (New York: Alfred A. Knopf, 2004), p. 563.
13. Albert Camus, *Lyrical and Critical Essays* (New York: Knopf, 1968), preface.

FIG. 2.1

Hanover studio.

A Conversation with Ben Frank Moss

Brian Kennedy

Based on interviews conducted on March 28 and May 7, 2008

BK: On your studio wall in Hanover [figs. 2.1, 2.2], you have a quotation by Albert Camus that says "A man's work is nothing but this slow task to rediscover, through the detours of art, those two or three great and simple images in whose presence his heart first opened." What were the first such images for you?

BFM: One of the images that I recall—it's reputed that I was two years of age when this occurred—I was walking along a wall. My guess is that it wasn't all that high, but it seemed to me that it was the height of my nursemaid's shoulders. She was holding my hand as I walked along and then she released her hand. I found myself walking without her support. That's an experience that had a very decided effect on me: a feeling of exhilaration—a feeling of independence that I could do this without her. It's something that is vivid in my memory. I suppose the other clear images would be of time spent in the woods. Throughout my time in school, I couldn't wait to get out of the classroom and be engaged by my imaginative life in the out of doors.

BK: In your studio there is a low table at which you work, and it looks very uncomfortable. You seem to sit simply, almost monastically, on a low stool. Can you describe your posture when painting and why it suits you to sit this way?

BFM: My relationship to my painting table and to my palette is determined by the work that I'm going to be doing. If I'm working on a piece that is large, then it's

affixed to my painting wall, and the level of my palette is calibrated to the extension of my arm with a brush when I'm standing. When I'm working on something small, then I do sit to work. I've never found it uncomfortable, but it's true, there is something rather formal within the setting.

BK: The layout of your brushes and other art materials is very orderly and meticulous [fig. 2.3]. How does order and disorder play itself out in your life?

BFM: I think it was Richard Hugo, the poet, who wrote many, many years ago in the *Atlantic Monthly* that poets are by and large very conservative. He meant

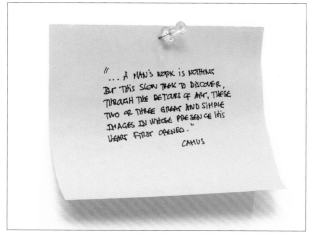

FIG. 2.2

Camus quote, Hanover studio.

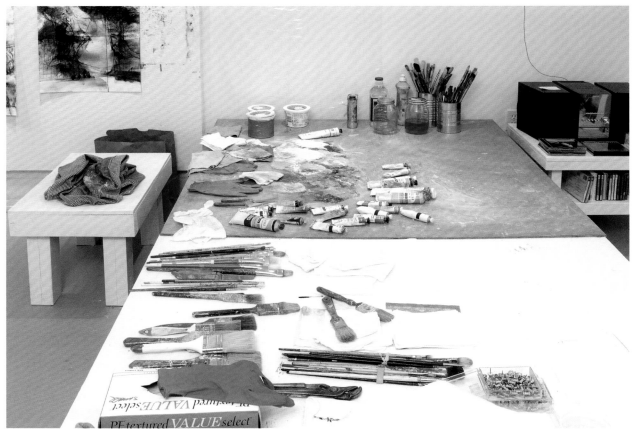

FIG. 2.3
Painting table, Hanover studio.

that they like to have a very ordered world because they're dealing with disorder in terms of the construction of their poetry. I found that rather comforting, because there is a clear sense of where my brushes are placed, where my tubes of paint are positioned on the table, and I want to know that's where I can count on them residing, so I can reach for a brush without thinking. Building the painting, that's where the confusion reigns; that's where the argument is ongoing. I try to get it into a state where I succeed at finding something I'm looking for. In support of that, I'm really dependent on that kind of order for the realization of the painting. The painting is where the chaos is forever in the mix, but everything else is very structured. There's a Flaubert quote that I'd like to give here. "Be regular and orderly in your life, like a bourgeois, so that you may be violent and original in your work." That's really applicable.

BK: Flaubert talks of being violent and original, but your work does not seem violent. Does that description apply?

BFM: Well, I don't know if the word "violent" is accurate, but certainly the idea of having liberty with no boundaries—that you can extend yourself without feeling that you're imposing yourself on others.

BK: I feel it's no accident that you referred to a poet. Do you see yourself as a visual poet?

BFM: Yes, a favorite poet of mine is Wallace Stevens,

who says that the poet is the high priest of the invisible. I think that's really apropos for the painter too. I have always admired work that has that registration of the mystery, of the invisible. Painters like George Inness, Morandi, Giacometti, and Howard Hodgkin. I have a list that goes on and on. But I understand that the painters I relate to are those whose work is very quiet and still, and often can be passed over. I look for what's revealed very slowly, but with real deliberation. So, poets have been of interest. My daughter is a poet and my wife has been absolutely obsessed by the reading of poetry as long as we've been married. That has been a standard gift of mine to her over the years for Christmas or birthdays: a book of poetry. So whether it's Emily Dickinson, Wallace Stevens, or Mark Strand, the poets I have real admiration for constitute a very extended list. It would include Mary Oliver, certainly, and I go well back with William Spafford, who was based at Lewis and Clark College in Portland, Oregon. I believe he was the Poet of Congress at one point. Anyway, his work I've always found to be really, really wonderful. And I was conditioned very early on by T. S. Eliot. A more recent poet I've admired is the Polish-American writer Czeslaw Milosz. And I'm currently reading Franz Wright, whom I find remarkable.

I should also mention that it's been my experience that when I want to benefit from someone's take on my work, it's often comments by poets and children that I have the most interest in. Poets have a command of the language, so they can appoint a word to the work and bring an insight that I have found really beneficial and interesting. Children, of course, are ruthlessly honest.

BK: You've mentioned that you always play music when you work and that your selections are quite calculated. In recent times, what music have you put on while you've been painting?

BFM: Almost without fail during my day of painting, I know that at some point I will listen to Bach. He has always been my favorite composer. Of late I've been collecting all of his choral works. I have great recordings of the Goldberg Variations by Trevor Pinnock, Glenn Gould, Keith Jarrett, and others. I was pretty much raised on Gould's interpretation of Bach. I've always

been very fond of the Baroque period, and Handel is another composer I love. There might also be a CD of folk music, but by and large, what plays in the studio is classical music. There are periods of particular favorites, like Bruckner. I went through a whole period of immersing myself in his work. Brahms and Beethoven never disappoint. Just today, however, I've been listening to Elgar, so it's very, very broad, from early to late classical, in terms of my interests.

BK: That makes for an interesting analogy. In your work, then, there could be almost a Bruckner phase, with his music playing in the background, which would be very important to you yet invisible to the viewers of those paintings.

BFM: Right. I haven't done this but I've thought it would have been of interest to look back on what music was playing at a given time. I could have recorded what I was listening to on the back of the painting. I paint, as you know, on paper, principally. I've never made such a record and have some regret now, because I think there would be clarification for me, as in the period when Bruckner seemed to be such a preoccupation.

BK: When you think of tone, color, harmony, and structure in music, how might that play through in the work at that particular moment?

BFM: It's never been a matter of illustrating the music through the painting, but I know that it has had a very decided play within how the painting is built. It's very much at the subconscious level.

BK: In your studio, in meticulous order applied on the walls, you have invitations to exhibitions, photographs, slide boxes, all sorts of things [fig. 2.4]. Would you like to talk about any of them?

BFM: I'll start with these photographs that I have on the wall [fig. 2.5]. There's a photograph of Walter Murch [formal shot of gentleman in dark jacket and tie], who was my major advisor at Boston University and a man who was remarkable in terms of extending himself to his students. I benefited from Walter—just

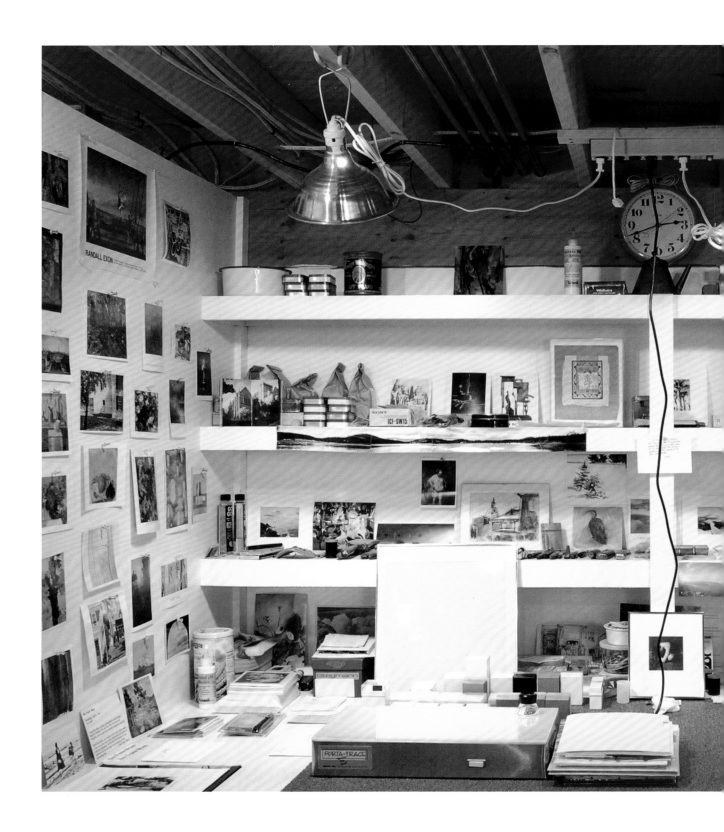

about every one of his students would make the same claim. Directly below his photo is that of Herman Keys, who was my undergraduate painting instructor. Herman had studied to be a professional violinist, and was one, until he contracted tuberculosis. That's when he discovered painting. He was in a sanitarium for two years and started doing some little watercolors, as therapy if nothing else, and that really took hold with him. He had an undergraduate degree from the University of Washington in music, but then he went to the Art Students League in New York and studied with Reginald Marsh and George Grosz. For me he extended the horizon as to what a real commitment was on the part of the professional artist. He had a studio in downtown Spokane, where in my senior year I was able to take an independent study. A fellow student went with me and we each had an easel, and we could watch him paint from time to time. That was incredibly instructive. It was really a model for what happened later at the Studio School we established in Spokane, where we wanted that kind of artist apprentice program to take place.

Walter Murch was Canadian, born in Toronto, and he came to the Art Students League right after the Second World War. It was then seen as *the* place to study in New York. He had heard about Kenneth Hayes Miller, with whom he figured he'd sign up for study. As he told the story, he had a very brief encounter with Miller and decided that he didn't want to have

FIG. 2.4, FIG. 2.5
Hanover studio desk and detail.

anything to do with what he was about. So instead he studied with Arshile Gorky, who had started the Grand Central School of Art in New York City. He related to Gorky in no small way because he saw him as a real mystic.

As a teacher, the whole thing for Murch was, who are you? What is the self? What is the personal voice that can be exercised in your work? He could discern what needed to be nourished and what needed to be encouraged by looking at your work. He was like a palm reader. His own paintings were full of incredible poetry [fig. 1.7]. I have difficulty trying to explain those paintings and appointing words. This is the greatest compliment that I can give them. Like Edwin Dickinson, whom he admired, and Joseph Cornell, whom he admired—there are a number of artists so defined who, like Murch, never received the kind of acclaim that is their due.

So, both Keys and Murch had a very profound influence on me by way of aesthetics and content. Herman was very much taken with narrative. This was because of what Reginald Marsh and Robert Henri and that whole school stood for. So much of what they were doing had been informed by the Great Depression and the focus was on those who were poor, compromised in health, people who were marginalized and disadvantaged. Herman thought that painting should have a message. I was a perfect setup for this, because I came out of a religious tradition within the church where stories about caring for the ill and those in need were ongoing. Religious subject matter was brought into it as well: the Crucifixion, the Resurrection, all of those Biblical narratives. I have to say that in this period of work there was an overriding sense of death; these were very grim paintings.

Herman's hero was Rouault. He was the ultimate painter. My paintings, in turn, had his strong influence of Rouault—the leaded line that encases everything and, of course, Rouault's tough subjects [fig. 1.1].

When I got to Boston University in 1961, one of the first things required was to write a paper about why we painted. Murch pulled me into his office and we had a conversation about my paper, which was all about my social realist heroes: Leonard Baskin, Rico Lebrun, Ben Shahn, Jack Levine, and George Rouault. Murch chal-

lenged the idea that painting should take this stance. I held my ground and said, "But look at the number of painters who have done this. There are periods of Picasso's work where he focuses on this, and certainly early van Gogh, all the 'potato eater' paintings." I kept referencing my heroes to him, saying "But what about . . . ? What about . . . ?" Murch was quick to admit that these were artists of real repute and was more than prepared to acknowledge them. Then he said, "Ben, why do you have to hit me over the head to make the point?" And he began talking about the poetic aspect of a piece. You can have layers of meaning within the work and the lyrical and the poetic also have a place. So that was my introduction to the painters he admired, those who spoke with a more subtle voice. It was for me to somehow resolve these two ideas. There's a quote from Emily Dickinson that I think applies: "The truth must dazzle gradually or every man be blind." That is in keeping with this idea of how subtlety can prevail in an effective way.

Another photo is of Varujan Boghosian, who was the senior faculty member when I arrived at Dartmouth College. I am indebted to him for his ongoing support. There should also be a photo of Isabel Bishop, who supported my work and became a friend.

BK: When you put these up on the wall, what way do they work for you? Is it for memory, memento, or souvenir?

BFM: Well, it's all of the above. It's an attribution of the respect that I've had for a number of artists. I have boxes of announcements and reproductions that aren't on the wall that I would be happy to see "in the company of these."

BK: On the far side of your studio wall, there is another quotation posted that says "Lead me from the unreal to the real. Lead me from darkness to light. Lead me from death to immortality" [Brihadaranyaka Upanishad]. Could you reflect on the issues raised by that quotation?

BFM: So now we're getting close to the bone, here! What seems to be associated with the whole experience

of producing a painting, a drawing—being engaged by this activity—is for me, in no small way, the awareness of a larger property within the universe. The mystery of life is what we're reflecting on by way of producing the art. It's a means, in my mind, of trying to give voice to what lies beyond—that indefinable something. As a person of faith, that is something that I identify as a supreme being, as God. There was a long period in my life when I found that I identified it as the "X factor," as opposed to actually using the name. It seemed in a way disingenuous on my part, because for lack of a better word, the word "God" could be applied.

I think that it's critical that you come to terms with the whole idea of death. It's something that was referenced when I was a child. I can very vividly remember the first death that I was aware of. It was of a very dear friend, a captain in the Army, who was killed during the Second World War. He was like an older brother to my sister and me. It became a question of what happens at one's death; how is this dealt with? So the quote is something I saw and it seemed to relate to those ultimate questions that I find myself dealing with, of who, what, when, why, and how.

BK: You've traveled to Spain, Portugal, Scotland, England, Germany, the Netherlands, and Australia. Have you ever wanted to go to Italy, and is there anywhere else that you really want to visit before you pass from the world?

BFM: I'd better make it quick! It would be Italy and France. I think subconsciously I've resisted going to those countries because they have factored so prominently within the world of art. I'm not an on-site painter. All of my work is developed out of my imagination. I'm not referencing something specifically; I don't stand in the landscape and paint what I see there.

Eastern Washington doesn't have the glow of what happens west of the Cascades. At that end of the state of Washington, it's picture perfect. If the sun's out—even if it isn't out—it can be visually so compelling. Whereas in eastern Washington, there's something that's dropped out; it's not so overwhelmingly attractive. So I think that my view of Italy and France is of a landscape that is just so incredibly gorgeous that it would be difficult for me to come to terms with. So, I see it at a distance. It remains in my imagination.

This happened for me in Australia. I had always wanted to go there and an opportunity presented itself where I could be in residence at Queen's College at the University of Melbourne. We ventured out from time to time, and one trip was to the Apostle Rocks that are outside Melbourne [fig. 2.6]. We hopped on a bus and arrived at the site. There was wind and a driving rain. It was incredible. As we stepped out of the bus it was like being sandblasted, but typical of the weather we experienced around Melbourne. We were the last to exit the bus onto a boardwalk to view the Apostle Rocks. I said, "Jeannie, I don't know . . ." and she said "Ben, for heaven's sake, look at all the rest of the people." All of them were dutifully marching forward. It was clouded over; you could see the rocks come and go out of the mist. It was just the sort of visual treat that I get off on, and then all of a sudden, just like the weather in Melbourne, everything lifted. The sun came out, the wind ceased, the rain stopped, and here were these amazing rocks that were just pulled up out of the sea. Jean grabbed my hand and said, "Ben, these are your paintings!"

"These paintings" were a series I had done earlier based on a memory of the landscape of the Columbia Gorge [cats. 7–18, fig. 2.7]. This is where the Columbia River separates Oregon from Washington and empties out into the sea at Astoria. So that's the reference for these paintings, but the truth of the matter is they were so much closer to the Apostle Rocks or the coast at Banden, Oregon, which I experienced just after graduate school. What I'm talking about here is a kind of wakeful dreaming. Jung talks about the collective unconscious. Where does this come from? What was this really all about?

In my wakeful dreaming in the studio, when I find myself in that "zone," so to speak, in which we all try to find ourselves, I haven't painted, to my knowledge, anything of Italy or France. But I see the landscape of those countries from the hand of other artists. Certainly everyone has berated me. Many of my painter friends have said, "Ben, this is just unforgivable." Jean would go tomorrow. She's more than ready to make the trip. So maybe it will happen within a year or two.

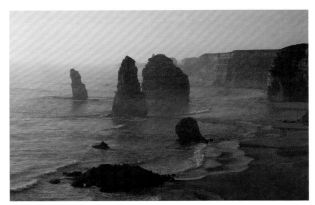

Apostle Rocks (The Twelve Apostles), Port Campbell, Victoria, Australia. © www.AustraliaFoto.com.

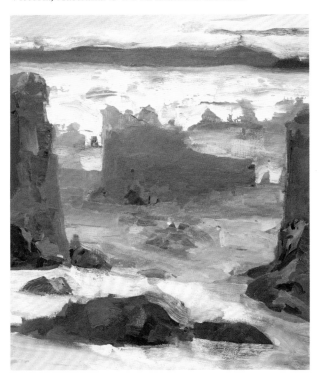

Memory of HFM (Helen Figge Moss) No. 2, 1991 (cat. 14).

BK: In terms of the Northwest, what is it about that region that satisfies you as a place to work?

BFM: It's about the deep space of the far West. I was born in Philadelphia and to the age of nine lived outside of Philly on the main line in Devon, Pennsylvania. Then my father took a pastorate in Huntington, Long Island, on the north shore. So all of a sudden there was water in my life—Long Island Sound and Huntington Bay and that area. When I was a sophomore in college, my father accepted a pastorate in Denver, Colorado. I had already been shipped off to boarding school, so I didn't feel a strong separation anxiety that I might have experienced at college, but I felt uprooted from where I was raised. I had never experienced any landscape like Kansas, Nebraska, eastern Colorado, or finally that huge range of the Rockies as I drove west to my new home in Denver. Then I transferred to a school in Spokane, Washington, so it became a drive from Denver to Spokane, going through Wyoming and Montana and ultimately just a little sliver of Idaho into eastern Washington.

My life since has been absorbed by that country. My father ultimately retired to Portland, Oregon. My sister married a college classmate who was raised in the Portland area. She now lives at Sunriver in central Oregon, and I have nieces and nephews who are all at that end of the country.

Again what holds me is the deep space. Two summers ago we took back roads to our summer home after visiting my sister in Sunriver. The landscape, the little towns we drove through—it was like being carried back into the thirties and forties—no big box stores. Here there are ranches of thousands of acres—big wheat country. We spent the night in Walla Walla— that's south central Washington. The next day we came upon this incredible rock that surges up from the flat farmland—Steptoe Butte. So we drove to the top. It was an amazing experience. When you're looking out over that landscape, you entertain the possibility that maybe this is what it looked like to the Native Americans. During that whole trip there was an abiding sense of a presence just so palpable within the whole area. For me it is still present in that part of the county. It's disappearing, but it's something that I've always related to.

When Jeanie and I were teaching at the University of Iowa in Iowa City, we, with our two children, dog, and cat, would travel back to eastern Washington every

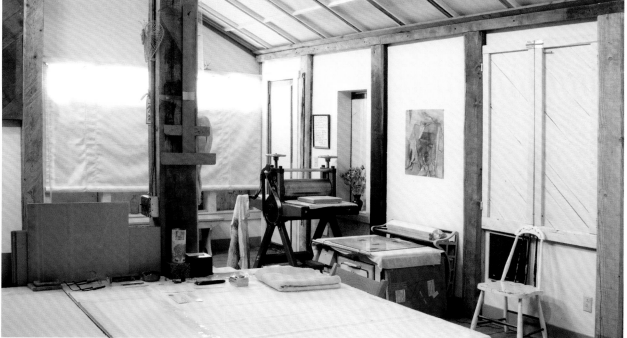

FIGS. 2.8, 2.9
Valley, Washington, studio.

summer. Before leaving for Iowa, we had purchased forty acres north of Spokane and with our own hands built a house that accommodates my studio [figs. 2.8, 2.9]. Two summers ago, we had an addition built with two bedrooms. So, it's grown over time but not out of control. It's now about five thousand square feet. As a result we have this huge emotional attachment to the place. We are the third owners from the homesteader, who was a Scotsman. That's how young this country is, still with a blush of the new, of the undiscovered. There's a personality too, of the people who have been there for three generations, that is very unique and distinct.

That's what carries me back. It's a visual thing, it's an emotional attachment, and it's this incredible sense of being close to a source that is in the air, in the rock, in the soil, and in the space.

BK: How do you feel about your work being described as "romantic" in spirit?

BFM: I think that's absolutely true. I don't apologize for that. I know it's not fashionable in many quarters. I know that my work in many respects has never been fashionable. I've found that I've identified with painters who aren't necessarily the stars of the moment.

BK: I suppose there's a corollary in terms of the sublime and the beautiful. How does the sublime relate to your work? When one looks at your paintings, there is a tension. It's almost elastic, to me anyway. There is this feeling of the beautiful and the poetic, intimacy, the sensual and sensuous at one sight, and then, particularly in the smaller paintings, of which there are many, a sense of large space, an openness into the world of possibility and of the enormous invisible [fig. 2.10]. It's a fine balance.

BFM: I hope that characterization is correct, but I'm not sure that I'm the best person to make the claim. I do think my paintings open themselves to the viewer. Clearly if you come to the work with a particular agenda, a particular theory or something that is a "template," it's very easy for the work to be dismissed, for it to be seen as anachronistic, without relevance today for painting or for art in general. But I think for those who look with some care and attention, they not only see a face that represents a certain kind of beauty and definition of the unknown, but they also can experience, I hope, that the work is realized through doubt. I don't come with preconceived ideas about what the painting has to be, that I've got it all set in my head, because that's not the way it works. It's always through the process of doing the painting that something is discovered. A closer observation might also show that there is this sense of loss and sadness that is rather pervasive.

BK: I wanted to ask you about that: this question of loss and absence, which is in counterpoint to the idea of discovery and accident within the work. Can you talk about the experience of personal sadness and suffering in your life and how it seems to have come through in your work?

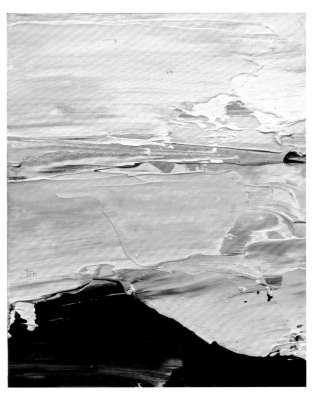

FIG. 2.10

Landscape Reflection No. 104, 2007 (cat. 36).

BFM: We live in a time when everybody's a victim. If you can't identify something that you've suffered through or been subjected to, somehow you haven't lived a legitimate life. I find that very tiring and wearing, the idea that the best work identifies with some sense of abuse or crisis. This goes back again to Murch's challenge with me, "How obvious do you want to make it?" There's so much work that is dependent upon the shock value. When death is portrayed, it must be with the utmost shock value. What I think often happens, nine times out of ten, is that the idea is used up just like that, and it doesn't allow for any expansion.

I think of poetry again. Great poetry opens the door, allowing you to walk into the room and, over time, to really discover that it is like a mirage, with the walls moving farther and farther away. Thinking of my content again, it is not that I set out to paint a sense of loss or sadness, but if I did, I hope that it's kept as an undercurrent within the work, as opposed to any clear signature spelling it out.

BK: To what extent does this relate to you going to Princeton's theological seminary? With your father being a Presbyterian minister, one would surmise that it was a potential career for you, too, and that the decision to move away from that pointed toward perhaps the humanism that is very apparent in your work.

BFM: Since I was a child, I identified with the ministry. When I was very small, after our noon meal on Sunday, my sister and I would set up a church and my parents and grandparents would be obliged to attend. I would reiterate my Sunday school lesson and my sister would pretend that she knew how to play the piano, we'd sing a hymn, and I'd meet the congregants and shake their hand as they would walk out. So one day my grandparents and parents became amused by something we did and that ended it. I was overly sensitive to their response, and they couldn't contain themselves with my performance. But, from the time I was very small, I was active in the church. I had leadership roles in youth groups and all of that kind of thing.

So I went to Princeton Theological Seminary, and I imposed upon myself a regime where I couldn't paint or draw. I asked myself, "Ben, can you live with-

out this?" It was absolute torture. The thing that saved me was that I talked my way into an upper-division class that allowed me to go to Trenton State Hospital, where I worked with a woman who was in a maximum-security ward under the direction of the chaplain, who was our instructor. I remember he asked all his students to write a statement about our life and our interest—about our philosophy of life. My paper was about my belief that the only reality was death—a very existential position. He talked to each of us about what we had written, and when my turn came, he said, "I've read your paper. Ben. You've talked a great deal about death, and death is certain. We all find ourselves at some point faced with this. But Ben, there is also *life!*" It was like a two-by-four just struck me on the side of the head. This idea was so simple. I found it incredible that somehow this was not something I had thought about, nor had someone confronted me with the obvious. But it was a time after the Second World War, when the Bomb was forever present. There was an ongoing sense that it all could just come down in no time, and so there were a lot of things that factored into my thinking.

I had some significant conversations with my professor about my consideration of the ministry and my attendance at Princeton and my painting. In any case, I finally realized I just couldn't live without painting.

In regard to your attributing humanism to my work, I should say that what I'm really looking for is the thing that is both present and absent, producing the ineffable. A good painting always raises a question and an answer. Those two concepts are held, producing a third state. It's like a balloon and a pin—two properties. You blow up the balloon. Then you take the pin, prick the balloon, and hear this blast of sound. That's what I hope the work retains. It's like a black hole. That's the closest I can give you by way of an analogy, where everything is sucked into this moment of time, and it's held in suspension. This is a very high ambition, I realize, and I hope at least in some works it occurs. If it happens, then the viewer can't describe or explain what they are experiencing.

BK: To use that too-often-used phrase, you are "a painter's painter," and I take that to mean that a

practitioner can recognize your love of your practice. Can you describe an equivalent to that sort of momentary hold that occurs in the viewer, the sense that you have when you know through your mind and your arm into your hand, and through your brush and into your paints onto the surface, that something's happening?

BFM: It's pretty much a state of feeling. I've used the words "wakeful dreaming." When I enter the studio, it's like walking into my very private world, where I can anticipate a gift being imparted. It's like going down into the water and submerging myself, and when it really takes hold, the painting is painting itself and I'm simply an observer of what's happening. And then it becomes a question of a realized position. Is it at that point where I think that something is being held? There are degrees, of course, within this. There are "ranges," but I never leave the studio without at least getting something I'm happy with. That doesn't mean I've succeeded in realizing a painting. Giacometti once said late in his life that he only worked for the sensation while working. That's really the sense of being acutely and totally aware. In that sense it's, I suppose, like a drug. I've never done drugs, but I hear one can experience an elevated state. It doesn't necessarily correlate that, if you've got that feeling, it's also in the work, but there are times when you are absolutely convinced that those two things have come together. Only time and the response of others will tell whether or not it's present in the work.

BK: When did you first come to believe that you could make small paintings and yet be taken seriously? You talked to me in the studio once about the influence of Persian miniatures, but also of the intimacy of Giorgio Morandi and Kurt Schwitters's paintings [fig. 1.8].

BFM: Right. It was Schwitters when it started but it was also a health issue. I was working in a very small studio that I had boarded up to conserve on heat, and also working on big paintings. I'd work for ten hours. I'd skip lunch because I hate having to break to eat when I'm painting and usually don't. At night when I'd get home Jean would smell my turpentine and oil on

my breath and say, "My word, Ben, I think I could light a match and torch you." And I didn't feel it until after I left the studio. So it was health and the influence of certain artists. I knew at the time, Brian, that small paintings were seen as effete. Action painting took place on a wall or floor, not an easel. Small was like, "Oh, come on, miniatures?" I was taken aback because I've never thought of them as miniature, although I've loved Persian miniatures. Recently I saw a group of them at a museum outside of Berlin. I'd go back simply to see those. They were just incredible. So, I've always taken the small paintings as seriously as I have any other size.

BK: I think that one of the logical consequences in using "miniature" with regard to your work is to imply that it's a mini-version of something larger. "Miniature," as I have conceived your work, means an illumination. "Miniature" is used in terms of medieval manuscripts, as is the word "illumination." This speaks very much to your work. The central concern of the work is that it illuminates. There are elements of the work that are for me related to icon painting and to stained-glass painting.

BFM: Do you know, Brian, there have been people who have—and this is self-serving, but for what it's worth—who have stood in front of the work and later told me that they found themselves crying silently, because they felt that they were a witness to a prayer. If that's true it would be great. I would be much complimented to believe that this might in fact be the case. And the other thing is, you know, De Kooning talked about wanting to make a big painting look as though it were small. So I take the reverse. I'm hopeful that these small paintings will also collect a larger sense of space.

BK: Can I ask you about figuration? Given that this exhibition focuses on your paintings from 1979, when you were already a mature man, it is noteworthy that we don't see any figures. Why?

BFM: You're absolutely right. Of all of the lectures I've given across the country (I think there have been more than ninety now), I have never in the Q and A

period had someone make the observation or ask the question you have just now: Why aren't there any figures? Sometimes in the drawings and paintings there are some architectural structures of houses, but there are no people in the windows or in front of the house or walking down a path or anything of the sort. I think the closest I've come to explaining it to myself is that I'm reaching for an absolute, a paradise of perfection, an ideal—that these paintings are about that kind of possibility of the Kingdom on Earth.

There's a great poem by Mark Strand called "The Idea," and it's really about a cabin that he sees in the woods and the weather from which he must seek protection. He needs to get to this place. It is the place Gregory Wolfe talks about when he says "I'm the poet of the in-between"—that it's there, but it's not there [see Wolfe's "Ben Frank Moss: Poet of the In-Between," p. 41]. In Strand's poem he gets to such a place, but you understand that it's something also of the mind. It's a figment of one's imagination. That's what these paintings are about for me. Again they assume that position of being there but not really being there, of becoming but not totally becoming. There's a statement from Native Americans that expresses the difference between the idea that if you believe in something you'll see it, and the way it is in the West, where we have to see it to believe it.

BK: It is a description of faith, isn't it?

BFM: Yes, that's exactly what it is.

BK: So in terms of paradise or heaven, the imaginary place is an aspiration to go where a believing person might go, and one would expect one would be reunited with all those other people who have gone there up to now. But aspiring to a place that is absent of people is the work of a landscape painter.

BFM: It's a bit of a contradiction, isn't it? Well, it's this Calvinist background maybe that I'm not aware of, the sense that we're imperfect, so don't screw up the landscape with the imperfection of our hand. The truth of the matter is that we have really worked over this planet. There's an awful lot that's still quite beautiful and untouched, so to speak, but too often where it's been touched it's not a very pretty picture.

BK: Is it related to that, then, again looking at the work? You paint wonderful landscapes. Unlike people, trees are clearly important to you. Whether we think of it in the work of an artist like Mondrian, who began to explore abstraction through his studies of trees, there is perhaps in your work, too, a sort of substitute figuration involved.

BFM: Well, I think there's a real animistic business going on. I've always found the hierarchy in nature, where we're the ones in charge, to be rather strange because I look at a bird, or any animal, or for that matter a leaf or the run of water, or a rock, and I often find myself saying, "Why is it assumed that this rock is without the properties that we ascribe to ourselves?" In time, isn't it possible? Scientists take just this little fragment of soil and put it under a microscope, and what you see is just incredible. It's endless in terms of what's there. It's just remarkable. So personally I see the landscape as this breathing, live property that is forever beyond our grasp. And I think it's so presumptuous of even the scientific community . . . you know, they get a little bit that they can hold on to and claim, and somehow they have the whole answer. I think it's also incredibly presumptuous of this fundamentalist position that they have the answer—the only answer. In my mind, nobody has the answer. We have clues, we have hints, we have the internal kind of intuitive sensibility and response, but it's ephemeral at best.

BK: In your charcoal and graphite drawings, the manmade environment appears in terms of bridges, walls, ships, and roads. They seem to provide a skeletal structure for the work.

BFM: Right. As a graduate student, I certainly discovered the use of the wall. That was an interior wall, but in time the wall has found its location in the landscape. When we traveled in Madrid and Portugal, we saw wonderful Roman viaducts. The architecture of those was so compelling to me. I also see this, in a sense, as a wall, but there is the opportunity to pass through it.

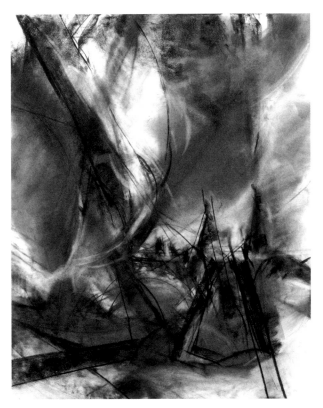

FIG. 2.11

Night Sail / Triangle Cross, 1992 (cat. 52).

The wall becomes a barrier, something to get around, get over. And I think the ship trying to make port is the same problem [fig. 2.11]. That's what I was seeing when they started to appear in the drawings, and that's where they have stayed. The elements are ripping everything apart on the ship and also at one point it catches on fire. Then there's also fire on the land. I saw these signaling devices and the idea of a buoy like a pyramid also on fire. It all seemed to come together in terms of an architectural use.

I just recently showed work to a museum director and a curator. I was showing some of the pencil drawings referencing the boats, and they immediately started talking about how architecture in this work in many respects is so different from the small paintings of the landscape. In my mind they are and they aren't, but I've never been that troubled by working within different claims. The most recent of these are the "boundary" pieces [cats. 65–68], or the "cardi-

nal point" pieces [cats. 69, 70]. The "boundary" pieces are pencil and they're rather ephemeral, representing a hedge, standing vined wall, or symbol. It's both an invitation and an opportunity to pass through or around, and at the same time it gives pause as to whether or not you have the strength, the will, to actually take the step to surmount the barrier.

BK: I find a group from the recent "boundary" series you mentioned tremendously impressive [cats. 65–68]. They concern what seems to me to be the Crucifixion and the Resurrection. They appear to take you from this sort of opening toward the blackness of the Crucifixion. Or perhaps in terms of the Biblical story, it could be the other way around, in that the darkness leads to the light of the Resurrection. There seems to be an extraordinary profundity in this series, and I just wondered about the motivations for it.

BFM: Actually, a lot of these were done at the College during my lunch hour or in the evening at home after a day in the studio. Often I start out using several pencils, moving them about in both hands. But the central location of open light or fluctuating space as a border is what seems important to the piece. Now something happened. I was making copies of my small ink drawings on a copy machine, simply for my files. Rather than copy one at a time, I was trying to put four on a sheet. At one point I misaligned them or something. I had them back-to-back or whatever, and all of a sudden, in printed form, there was a little rectangle in the middle, which was the pure white of the paper. In addition there were all of these ink marks. The combination made what looked like a cross. I think you saw two of them in my studio. I'm not sure that I could ever replicate anything like them again. It was like a gift. I have never consciously made "The Cross" per se, but I have seen it in the work. I'm glad you made that association with the pencil pieces.

BK: Students I've spoken with—your students—have attested, and very strongly, to your qualities as a teacher. I want to ask you to reflect on your career as a professor and as a practicing artist and the way that one has fed the other.

BFM: I feel that wherever I've worked, I've been very fortunate in that I've been provided a schedule and support where the artist has been acknowledged as having value. I'm also fortunate in that I've had wonderful students. One of the ways I've succeeded is that, wherever I've taught, I've always said to my students on the first day of class, "Look, this is the contract. I can't kick you out of this class. You're the person who makes the decision as to whether or not you want to stay or leave, but up front I think it's important for you to understand what my expectations are." At Iowa, as a state school, we could close out our sections at sixteen by enrollment, but I never established a cap. What would happen is that it would float up into the thirties. The first day of class after my statement at least fifty percent would drop and often I'd get it down to fifteen. Those fifteen students were just wonderful. They were there to work. When I did it my very first year here, nobody dropped. To the students at Dartmouth it was a challenge: "Okay, I'll show you! I'm up to this." So that was refreshing.

I've loved teaching. I've taken it very seriously. I've worked hard at it. I have to say that at the end of every summer I resented leaving my daily life in the studio, not having that ongoing connection with painting. I didn't want to go back. But once back, it was great, because students always rewarded me on so many levels. I've always said to them, "You know, I feel that I've gotten the better deal here. I really feel blessed that I've been able to work with you. I hope you've gotten something in turn from me." With graduate students, more often than not, they were like point people. After a spring or fall semester break they would come back to class and say, "Ben, have you seen . . . ?" So I was introduced to many painters that were just coming on line. I was very well served by my students' motivation, curiosity, and dedication.

BK: Well, Ben, congratulations on all of your fine work as both an artist and a teacher.

Appreciations of the Artist

A Reflection on the Work of Ben Frank Moss

Late in the twentieth century, many art theorists proclaimed painting dead—that is, its relevance to the politicized discourse and aesthetic strategies of late modernity had come to be seen as suspect. In such a polemical atmosphere Ben Moss continued to make luscious, painterly images—often of essentialized landscapes, seascapes, and skyscapes.

When much of contemporary art was mired in the heavily theoretical and political, Moss was articulating a sophisticated and nuanced vision of the American sublime—very much in the tradition of Cole, Bierstadt, Inness, and Burchfield—yet one that was contemporary and fresh and cognizant of the losses of the twentieth century. His work quietly affirms that whatever the momentary storms of rhetoric may be, there is always a place for meditation on the beauty and significance of the natural world and its ineffable laws and powers. It is not that the political realm is denied or bypassed—his is simply a statement about what remains, no matter the ups and downs of human wrangling.

In Moss's work, paint is a palpable metaphor for space, for light, for substance. There is no trace of the self-referential and no sense of the detached "cool" of high postmodernist irony. These are revelatory meditations on the "thus-ness" of things. A streak of viscous cerulean traverses a knife-trace of vermillion and sonorous green-gray, and we receive at a gut level the evocation of horizon and air, earth and sky. Like his forebears in the American landscapist tradition, Ben Moss expresses something essentially American: trust in the land, in the river, in the wheat and corn and the fruit tree. In a word, the garden.

This may seem a homely subject—the garden—but the work of Ben Frank Moss is more than simply *reportage* on a subject. It is an attempt to reveal to his viewers a vision of what is universal in our response to nature. The small scale of Moss's work is a surprise in this context. Often in the history of American landscape painting, the open vista is everything—and consequently the scale of the art echoes that motif. But with Moss we are invited into an intimate meditation on massive forces—like Moghul miniatures that detail large expanses of interior space or a major military campaign within the confines of a diminutive frame.

Beyond all of this I would offer a personal reflection that I hope is fitting in the current context of the Hood Museum of Art and the exhibition. I believe that Ben Frank Moss is an artist in multiple senses of the word. His teaching, his tireless support and encouragement of younger artists outside the confines of his Dartmouth classrooms, and his vision of art as a *conversation*—all this points to the same insight contained in his paintings: that what persists, after the dust settles, is the dialogue—with nature, with our common humanity—itself a part of the land, the river, the sky, and the garden.

Bruce Herman

Bruce Herman is a painter living and working in Gloucester, Massachusetts. He studied under Philip Guston and James Weeks. He is Lothlórien Distinguished Chair in the Fine Arts at Gordon College in Wenham, Massachusetts. His artwork has been exhibited in solo and group exhibitions in eleven major cities, including Boston, New York, and Los Angeles, and in England, Italy, Canada, and Israel. He is represented in public and private collections including the Vatican Museums in Rome and the Armand Hammer Grunewald Collection at UCLA.

A Vision of Faith

As the rays of the evening sun glide through the open portal of St. Francis's Basilica in Assisi, there is an auspicious moment when warm beams of light gently embrace the surface of Pietro Lorenzetti's *sacra conversazione*. At this propitious moment, the mysterious alchemy between gold and light initiates a marvelous and exalted transformation. The noble gestures and silent exchanges between the participants become illumined and charged with a profound and resonant inner sacredness. One can only stand mute before this meeting of the tangible and intangible. The softly shimmering golden ground assumes a metaphoric aspect, combining the depth of awe and a sense of the holy present in the everyday.

More than half a millennium distant from the glorious walls of Assisi, the paintings and drawings of Ben Frank Moss convey his sense of reverence and certainty through the same transforming and mysterious participation of the divine and the material. Moss's elegant paintings, which appear effortless, as though possessed by a similar Assisian lightness, have developed steadily and reflectively. With patient and probing sureness they unfold to assume luminous form, a painted vision given substance by the conviction and exercise of faith. While some presume an impenetrable division between nature and the divine, Moss, by contrast, accepts a reality composed of one seamless fabric. It is one that retains a profound, but unpretentious, recognition of a greater light and presence living among us. In this view, paradox is not only acknowledged but also unhesitatingly embraced.

Moss stalwartly pursues the landscape as image and as metaphor, believing that the act of painting is still capable of imparting truth. Even as the complex skeins of paint accumulate, hover and merge, as colors amplify and extend the limits of their appointment, the colors' retention with their origins is dissolved, plasticity is transformed by the essence of the spirit, and spirit assumes corporality within the pigmented surface. Through this exchange, the restoration of the divine claim to nature is given remarkably full voice. Much like the modest Leipzig motets of Bach, in which the disparate voices assemble, harmonize, and interweave, each distinct yet all together forming a unified intonation, these intimate paintings and rich drawings speak of joy, of hope, of expectation.

Ben Frank Moss's conviction about the dynamic potential of the landscape to invoke a restoration of its divine beginnings is a vision of possibility, an anticipation full of faith. In these works, the tangible is once more clothed by the intangible and we are admitted as participants before a vision in which the *sacra conversazione* continues, uninterrupted by temporal or spatial concerns.

Jeffrey Lewis

Jeffrey Lewis is a Professor at Auburn University in Alabama, where he has taught painting and drawing for twenty years. His encaustic paintings and silverpoint drawings have been exhibited nationally and internationally, including a one-person exhibition at the Montgomery Museum of Fine Art in Alabama. Lewis has held residencies at the MacDowell Colony, The Henry Luce III Center for the Arts and Religion at Wesley Theological Seminary, Washington, D.C., and the Pouch Cove Foundation. His teaching experience includes positions at Dartmouth College and Cornell University as well as guest lecturing at American University, Mississippi State University, Birmingham Museum of Art, Alabama, and the University of Wisconsin, among others.

Ben Frank Moss: Poet of the In-Between

In Plato's dialogue about love, the *Symposium*, the philosopher Socrates claims that much of what he knows about love he derived from conversations with a priestess named Diotima. As a figure of both wisdom and sacred power, Diotima's words have the force of both reason and revelation. Love, she says famously, is a longing for immortality: "True love is a desire for perpetual possession of the Good and Beautiful."

But for me the most fascinating thing Diotima says—and the concept that puts me in mind of the achievement of Ben Frank Moss—is her statement that love is less like an extreme or absolute value than it is like the golden mean. In other words, Diotima says love calls us to live fully in the tensions of the in-between (*metaxy*). We inhabit the place between immanence and transcendence, life and death, subjective and objective, yearning and fulfillment.

In an essay on the relationship between art and *metaxy*, scholar Glenn Hughes writes: "True works of art are in fact born in the love that mediates between world and divine mystery, and in truly appreciating them we are moved to re-enact that love, with its spiritual simultaneity of yearning and fulfillment."

For me the art of Ben Frank Moss has always exemplified this vision. In a fundamental sense, his landscapes inhabit a zone between abstraction and representation. Nature remains "the given" to which the artist responds. But the artist is not mere imitator; his drawings and paintings interrogate nature, striving to see it in relationship to something within and yet beyond itself. In so doing, the subjective making of the artist echoes and reenacts the making at the heart of creation itself.

To encounter a work by Ben Frank Moss is also to be reminded that great art exists in the in-between place that brings the artist and the viewer together. Thus the artist's interrogation becomes the viewer's questioning as well—a joint exploration of the world and its mysteries.

How else to explain all this except as an act of love—love for nature, for the gift of art, for the humanness of those who engage both art and nature? In an era that has been dominated by notions of art as either an extension of the ego or of some impersonal political or economic system, Moss shows us a different path. Ben Frank Moss is a poet of the in-between.

Gregory Wolfe

Gregory Wolfe is the publisher and editor of Image, *a quarterly journal, and director of the low-residency MFA in Creative Writing program at Seattle Pacific University. Among his books are* Intruding Upon the Timeless: Meditations on Art, Faith, and Mystery; Malcolm Muggeridge: A Biography; *and* Sacred Passion: The Art of William Schickel. *In 2005, he served as a judge in nonfiction for the National Book Awards.*

Ben Frank Moss: Notes on Technique

Excerpts from interviews with Brian Kennedy on March 28 and May 7, 2008

BFM: It might be of interest to know, in terms of my process as I approach the painting, what precedes the actual execution. If I'm working on one of my larger paintings, I typically take three to five one-pound tubes of white paint and squeeze them all onto the palette. Then I condition this paint with turpentine. There's a great deal of time spent in mixing and getting the right consistency. I want it to be less stiff than what comes directly out of the tube. Something more like whipped cream. Then I frequently will add just a bit of Mars black in this mix. You have to imagine that I have a large puddle of paint and from that I start mixing my colors. I'll add a color, such as cobalt blue for instance, and then I continue to build a whole series of colors that I anticipate using for the painting. I'm not thinking specifically about a given blue for the sky or for the water. I know that if I'm mixing blues, that they will have a multiple function if I am painting a landscape. I will have spent a good five hours mixing colors that I know will serve the painting (I'm referencing the larger pieces) for about three days. It doesn't mean that I don't mix other colors as I start the painting, but I want to have enough paint present so that I don't have to re-mix or figure, "Where did that color come from and how do I operate with that?" So that's all carried on the top of my palette and if I'm working on a small painting, there's less of that involved. I anticipate how much paint I'm going to need for what I'll be working on.

BK: I am looking at a photograph of your art materials [fig. 4.1]. Could you describe them—why you use what you use, and what all the implements are for?

BFM: The photo is of my palette. I don't typically work with gloves. There's a pair of gloves on the table. I strongly recommend to my students that if they're working with cadmiums, or particularly if they're working with lead white, they might want to have a pair of gloves on.

I'll start with white. For years I worked with lead white, which I really loved because it gave this silvery kind of gray light. Also, technically, I'm well aware that it produces the best skin in terms of the paint film because it is more receptive to expanding and con-tracting. Lead white is the warmest white, and that's another feature, plus the fact that it has a wonderful drying capacity. It dries rather quickly—that is, it oxi-dizes rapidly. Zinc white, being very cold, is a white I never use, and it creates a film that is unstable. So when flake white was taken off the market momentarily

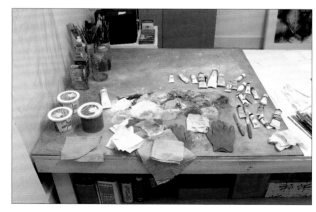

FIG. 4.1

Artist's palette, Hanover studio.

43

and wasn't available to artists, then it became a question of "What can I use?" When I first started painting as a student, you could buy from Dutch Boy (the manufacturer of commercial paint) tubs of lead white. I used to buy it in quantities of twenty-five pounds. Although not refined, it was great for laying down as a foundation on the canvas, panel, or paper. So when it was removed temporarily from the market, I went to titanium white. This is a compromise in many ways between the warmth of lead white and the film that it creates and the opposite extreme of zinc white, which is so cold and gives you a less stable paint film. It took me a while to adjust to it.

My palette in the Northwest makes more visible the way I arrange my paints. White is typically in the upper left-hand corner and black in the lower left-hand corner. From white, there is the registration by temperature and value. My reds go across the top. Then going down the side, I go into my blues and greens and browns, and finally I have Mars black, a good stable earth color, at the lower left side. Ivory black is very susceptible to cracking, and I don't use something like Payne's gray either.

When I set up my studio here in Hanover and built my new painting table, I laid down a piece of Masonite, which is the palette that holds the oils. Once my tube colors are placed, there's a second row of colors that are registered against them. There are certain colors that I favor—blue, for instance. It's not something that is acidic in nature. So often blue comes out first and I mix colors that give me a range of blues. I'm talking about cobalt blue, Prussian blue, and ultramarine blue. Then, in terms of the warm colors, there's cadmium red light, cadmium yellow deep, and alizarin crimson.

Linseed oil is the binder that dry pigments are mixed with to make oil paint. The rule of thumb as you paint is that it's fat over lean. So you don't begin with linseed oil. You start with turpentine, thus keeping it lean. As you build up the painting, you begin to add linseed oil. That's the whole idea of fat over lean, because your paint is immediately starting to set up, and as you build the painting, you want those films to interact in such a way that cracking is avoided.

There are three types of linseed oil available. One is standard cold-pressed linseed oil. That's what most

students typically use. Secondly, there's stand oil, and then there's thickened linseed oil. I began using sun-thickened oil at Boston University, and I am still using it to this day. It's very hard to come by. When you look at catalogs today, they don't list it, and many students make the mistake of believing that stand oil is the material that gives that beautiful textured effect retaining the brush stroke. Sun-thickened linseed oil is simple to make: pour regular linseed oil into a shallow saucer, place a piece of glass over the top so it doesn't get contaminated, and set it in the sun on a summer or spring day. Over time it oxidizes and starts to thicken. What I do is mix my sun-thickened oil with regular linseed oil and turpentine. This combination is put in a bottle so I know that I have the same consistency every time it's used. This is my painting medium. This is what gives the luscious wet look to the paint. I like the wet look as opposed to the dry, although I'm not offended if dryness works within a painting.

What you're really doing when you're applying paint heavily, as I'm doing, is setting up a tension between one stroke and another. Van Gogh, for instance, applied paint heavily and painted directly. For any of us who look at his painting, it becomes of interest whether it's been applied with a knife or with a brush and how one stroke works against the other. When you look at a painter like Auerbach or Kossoff, two painters I admire, they apply a heavy application of paint so that in many cases it is in relief. You wonder how they succeed in building the paint so that it finally assumes that state. So this is something that's important to the work, the addition of linseed oil.

BK: Can I ask you about your brushes and palette knives [fig. 4.2]?

BFM: For the end result, the tools of the artist are absolutely critical. De Kooning had brushes specifically made that would give a whipping look to the paint. Those were on the market and I purchased them when I was a graduate student in Boston, knowing that De Kooning got that kind of effect. This was a long bristle, as I recall, about two inches, and the handles were also extended. When you dipped that brush into paint that was rather fluid and applied it to the surface,

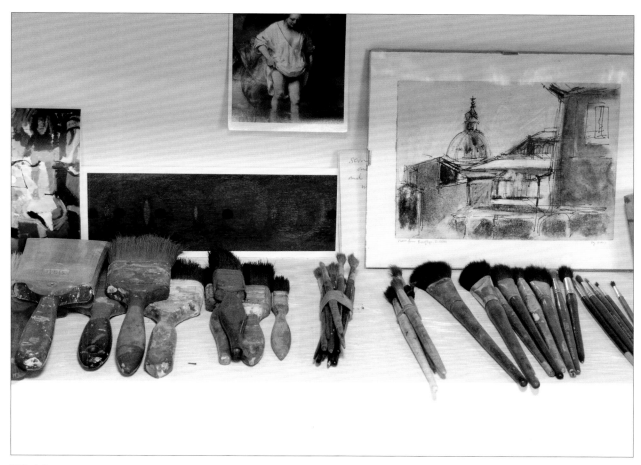

FIG. 4.2

Artist's brushes, Hanover studio.

you could get this turn within the mark because the brush itself had a spring to it.

The abstract expressionists used many commercial tools. As we know, De Kooning was a commercial painter in Amsterdam, and there were certain techniques that he applied to his own work. The brushes of a commercial painter were in use by American painters early on. As a student I had already begun to use a three-inch housepainter's brush—a natural bristle brush, by the way. At that time, the nylon bristle brush wasn't available. I had a three-inch brush, a two-inch brush, and a one-and-a-half-inch brush with a very shallow heel. I wanted the long bristle because of its flexibility and movement. This goes all the way down to very small brushes.

We used to use sable brushes. Giacometti's surfaces are very painterly, and the physicality of paint is critical to what that work is about. He used a sable brush and thinned-down paint. A sable brush has such a soft touch on the surface, and that's how you can paint wet into wet indefinitely. Now that there are nylon brushes available that are also very soft, I utilize them a great deal. It's not that I don't use a stiff-bristled brush, but the minute you apply a bristle brush, you dig, you track into the paint, and before you know it you have nothing but mud on your hands. The hope is to keep it fresh. I discovered as an undergraduate that the way to achieve this—painting wet into wet—was to use sable or soft nylon brushes.

Plates

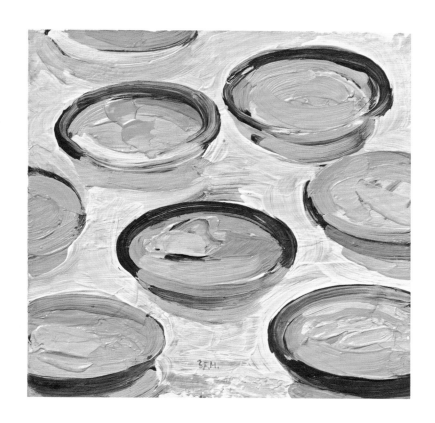

PLATE I *Eight Shallow Dishes,* 1979 (cat. 3)

48 PLATE 2 *Two Boxes with Orange and Blue Ribbon*, 1979 (cat. 6)

PLATE 3 *Orange Fish Bowl,* 1979 (cat. 4)

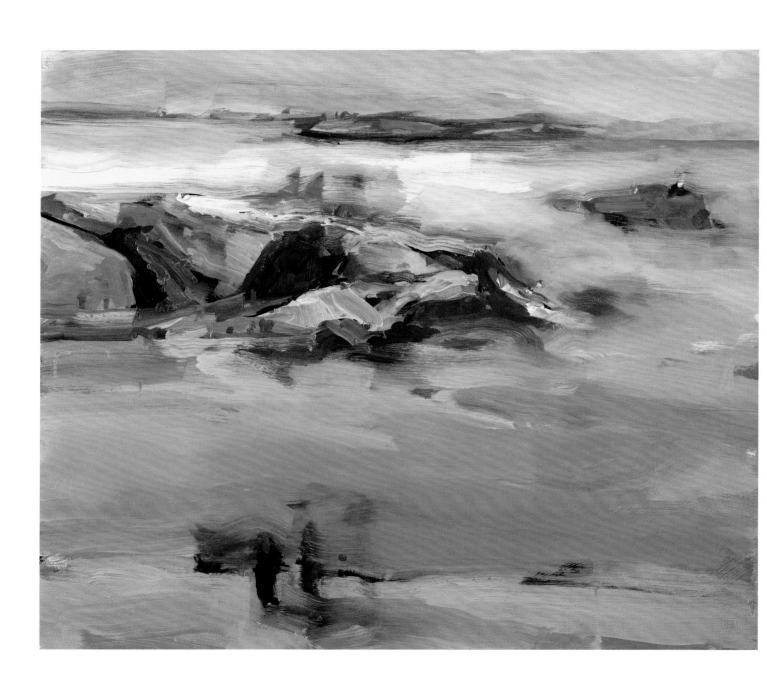

PLATE 4 *HFM (Helen Figge Moss) Memory,* 1989 (cat. 7)

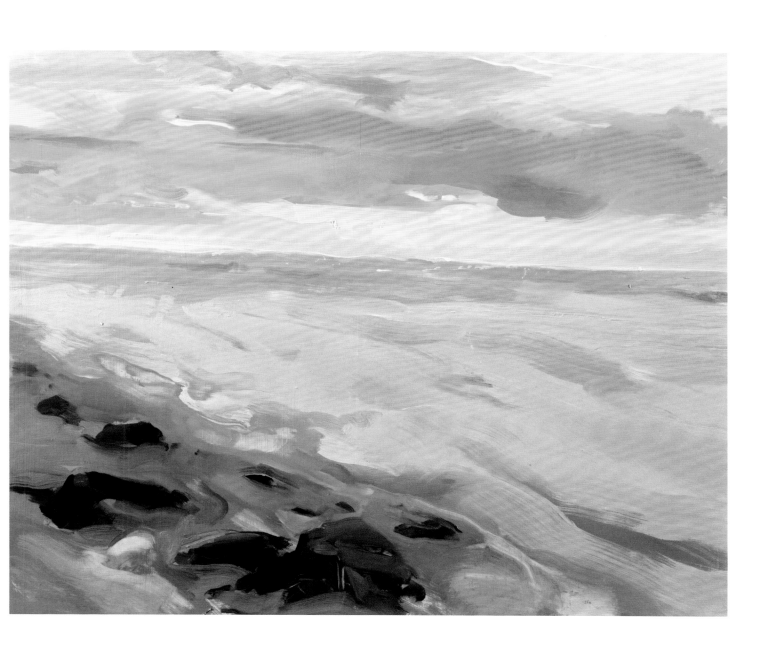

PLATE 5 *Warmth of Light,* 1989 (cat. 8)

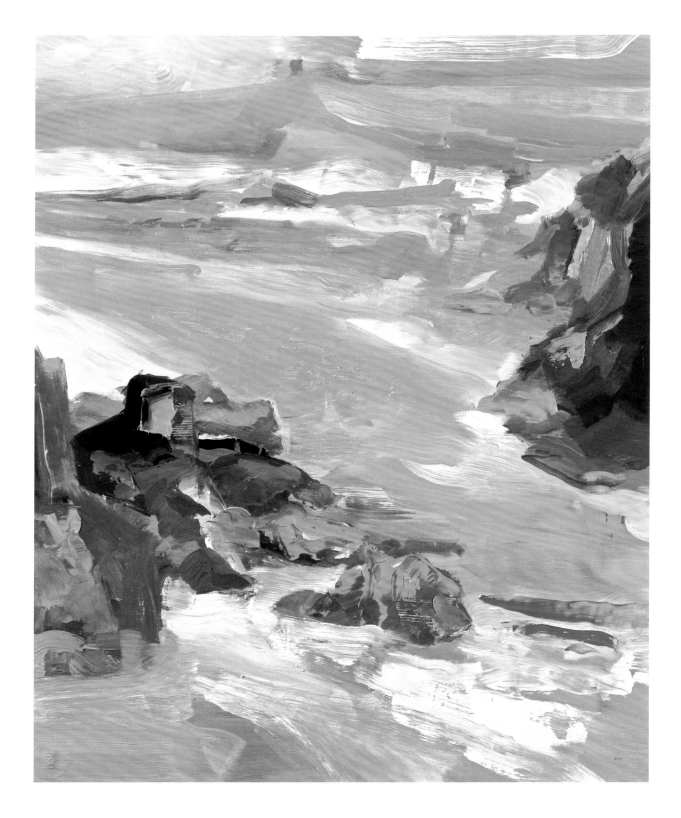

PLATE 6 *Day Watch No. 2*, 1989 (cat. 10)

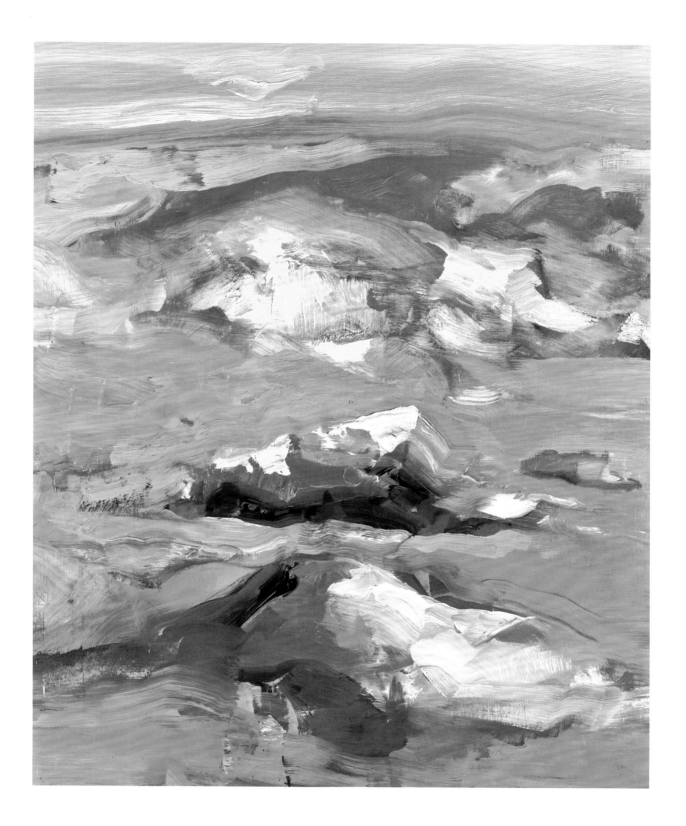

PLATE 7 *Island Dream No. 4*, 1991 (cat. 12)

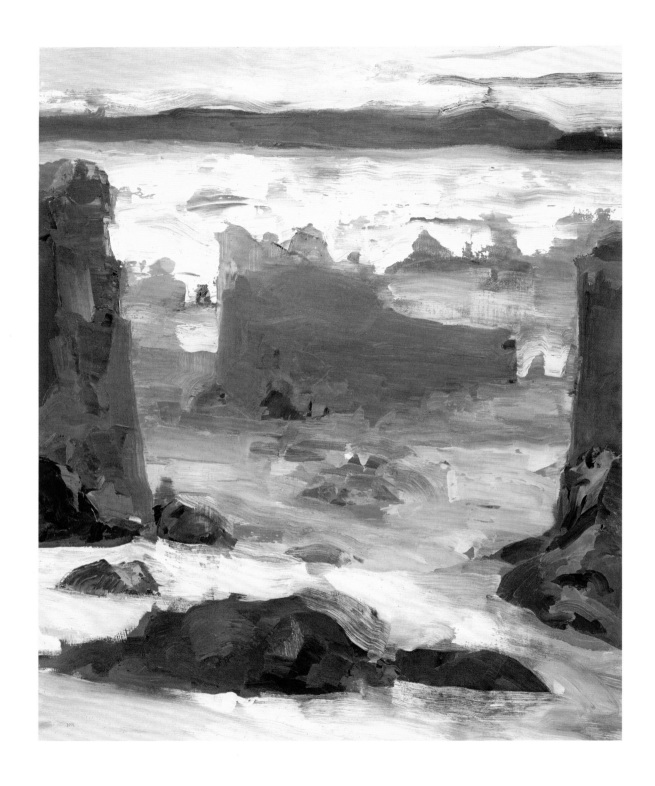

PLATE 8 *Memory of HFM (Helen Figge Moss) No. 2*, 1991 (cat. 14)

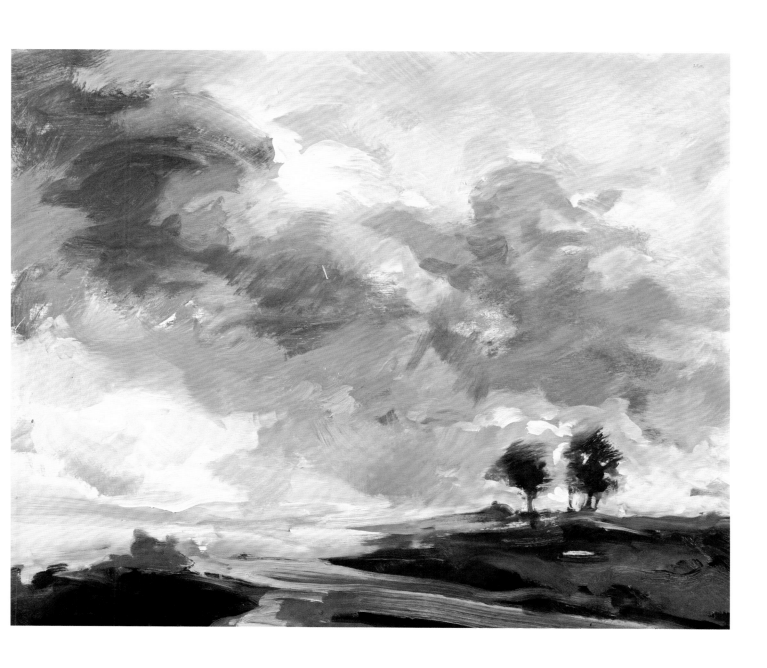

PLATE 9 *Columbia Winter,* 1991 (cat. 17)

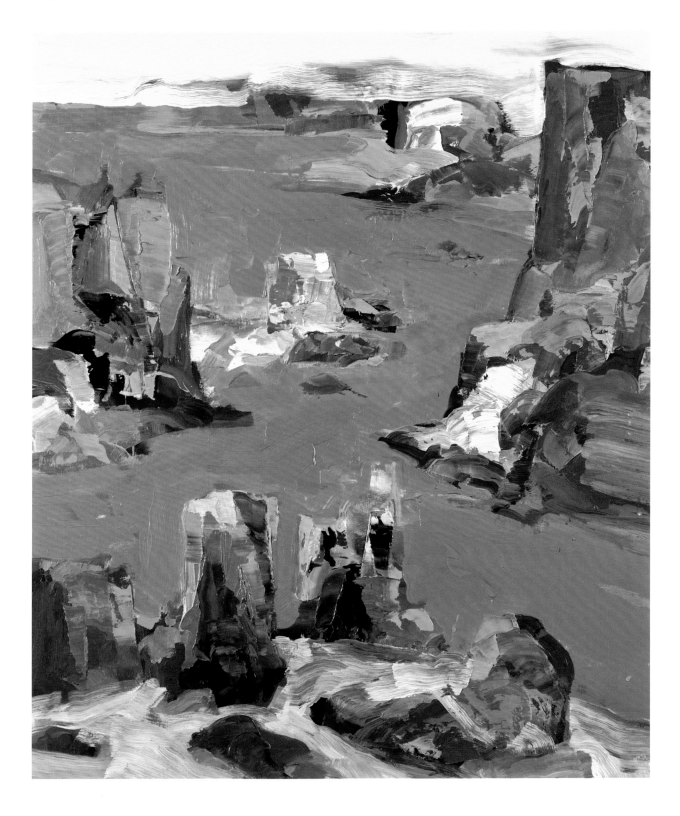

PLATE 10 *Columbia Summer*, 1991 (cat. 16)

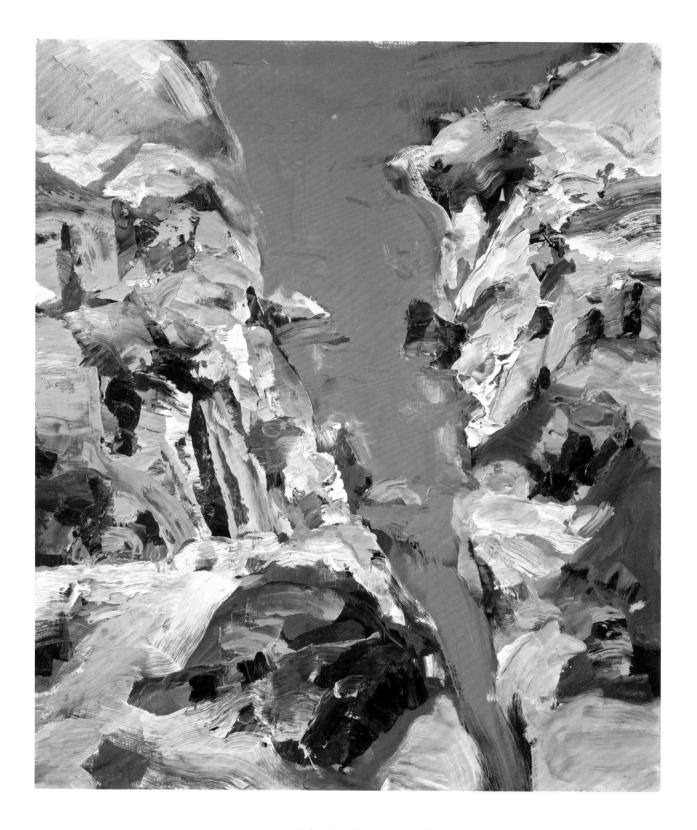

PLATE II *Columbia Dream*, 1991 (cat. 18)

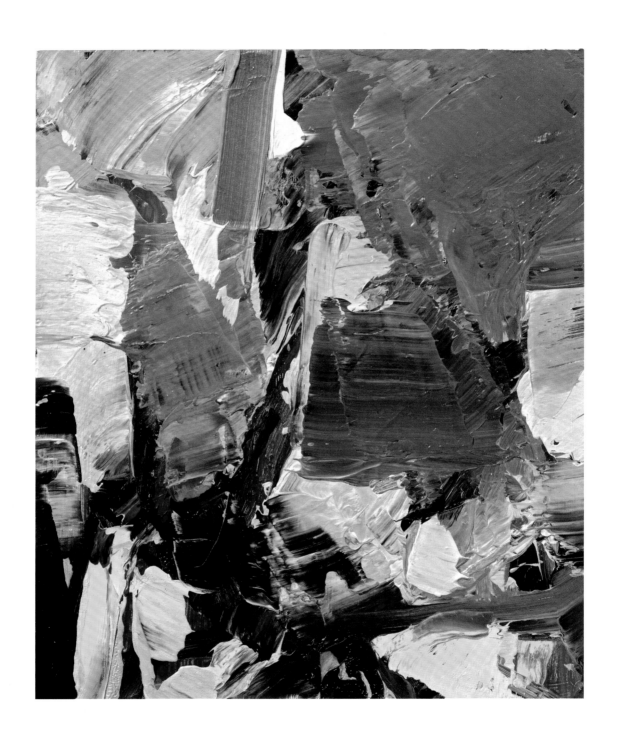

PLATE 12 *Passage Remembered No. 1,* 1994 (cat. 21)

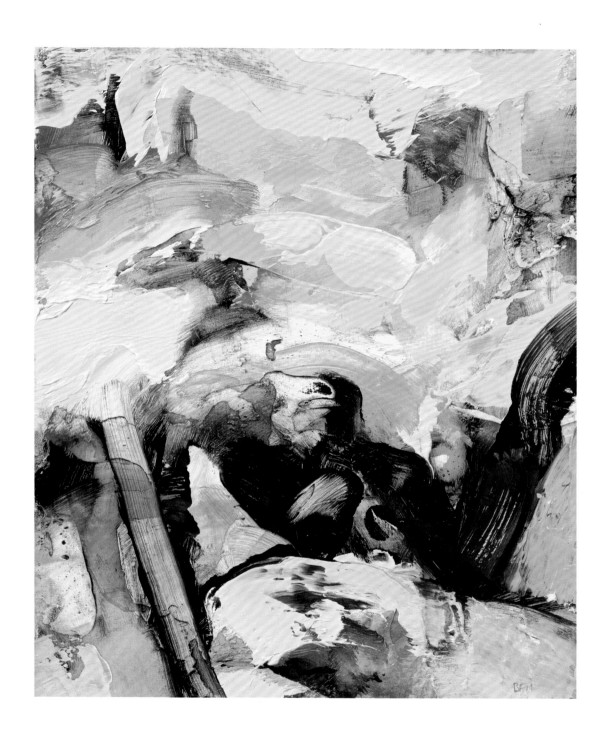

PLATE 13 *Keeping Watch No. 1, 1993 (cat. 19)*

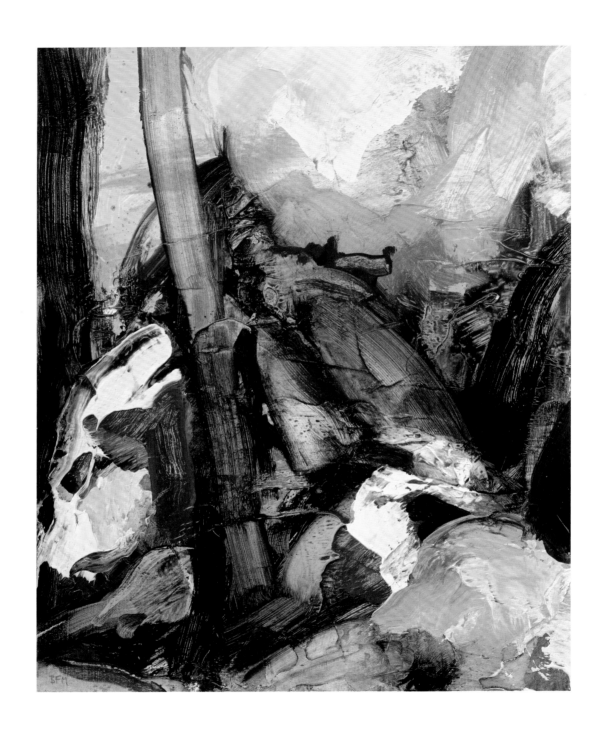

60 PLATE 14 *Expectation No. 2*, 1993 (cat. 20)

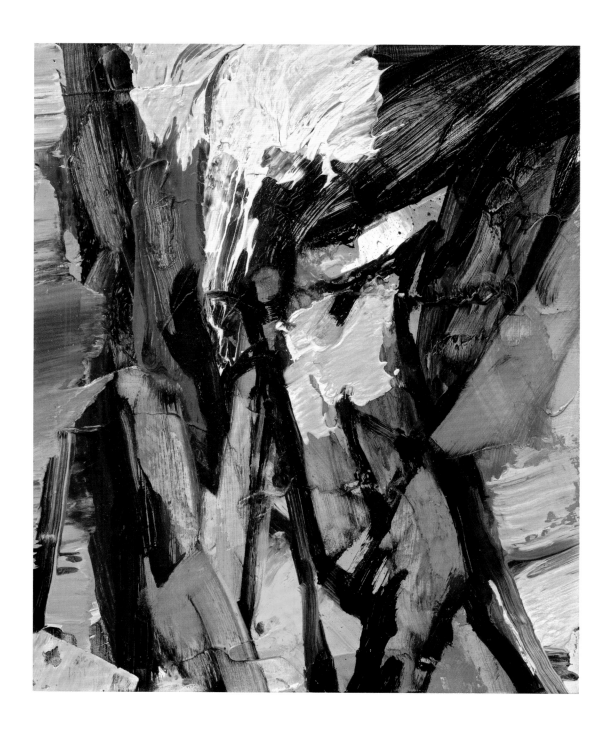

PLATE 15 *Ascension Fire No. 4,* 1994 (cat. 22)

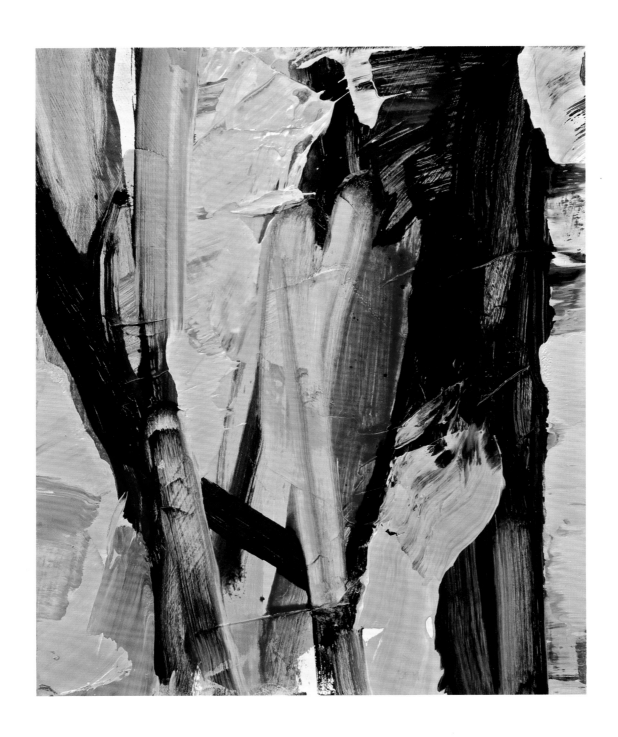

PLATE 16 *Ascension Fire No. 6, 1994 (cat. 23)*

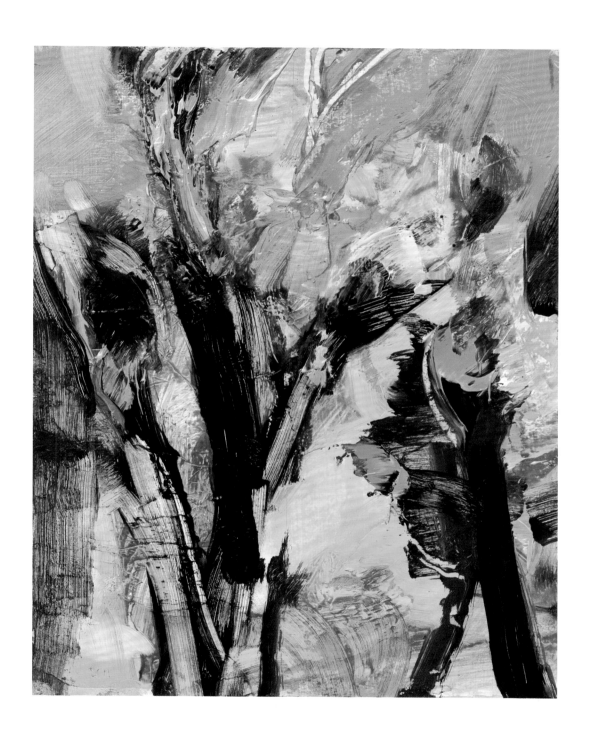

PLATE 17 *Garden Paradise No. 19, 1998* (cat. 24)

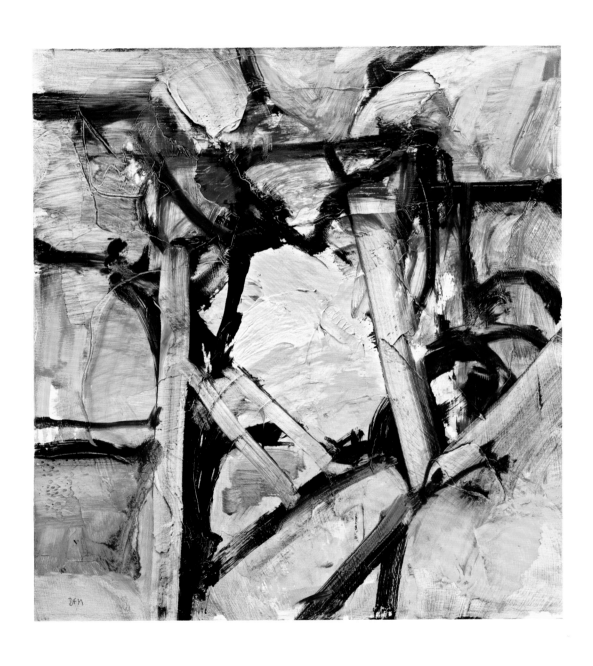

PLATE 18 *Garden Gateway No. 6, 1999 (cat. 25)*

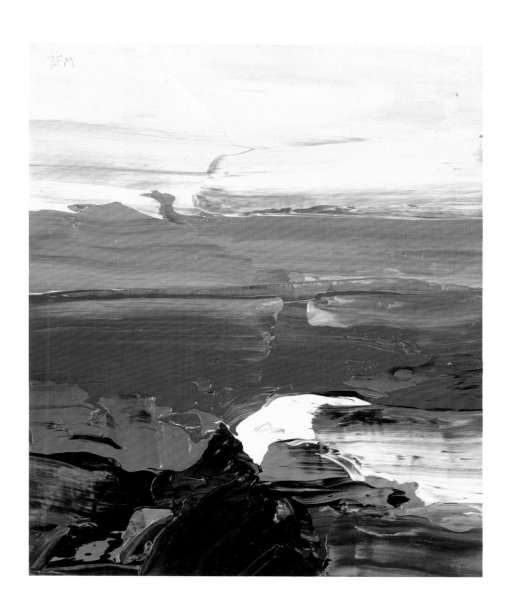

PLATE 19 *Landscape Sound No. 144, 2002* (cat. 29)

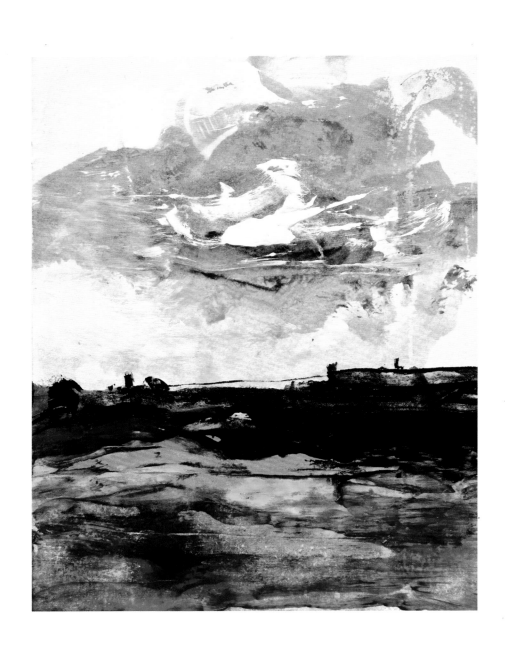

PLATE 20 *Landscape Reflection No. 24, 2005* (cat. 30)

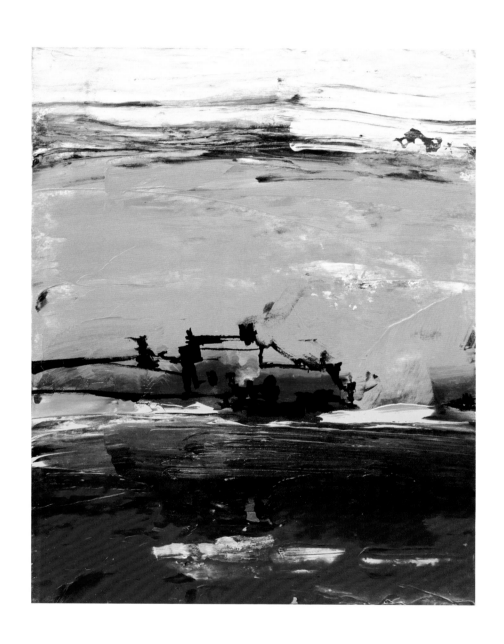

PLATE 21 *Landscape Reflection No. 28, 2005* (cat. 31)

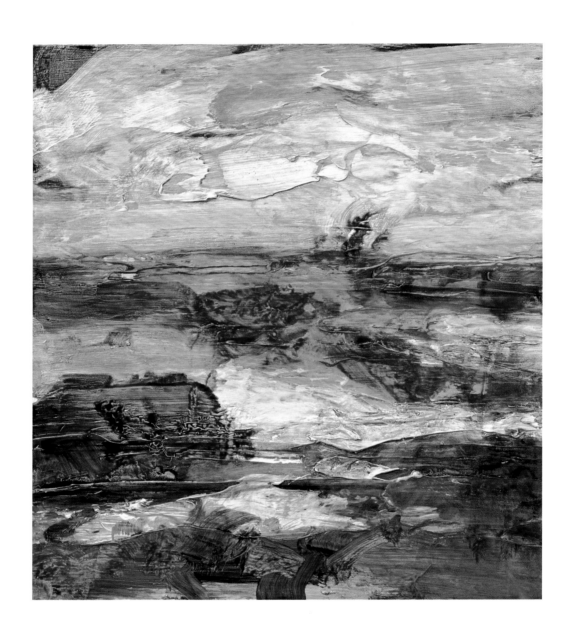

PLATE 22 *Landscape Reflection No. 75, 2007* (cat. no. 33)

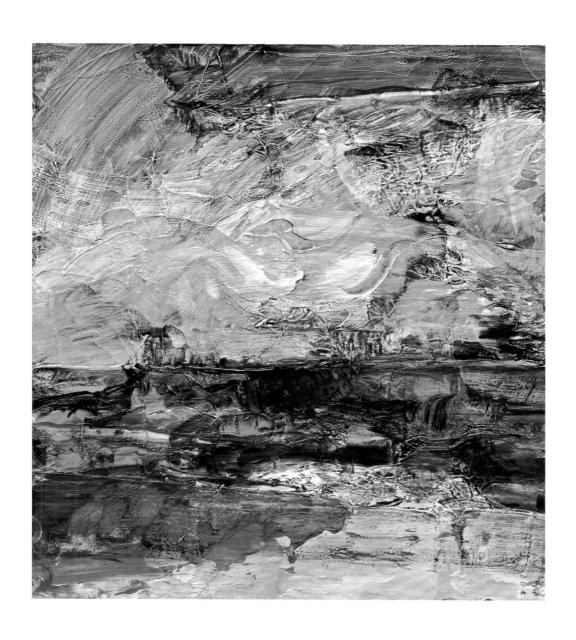

PLATE 23 *Landscape Reflection No. 76, 2007* (cat. 34)

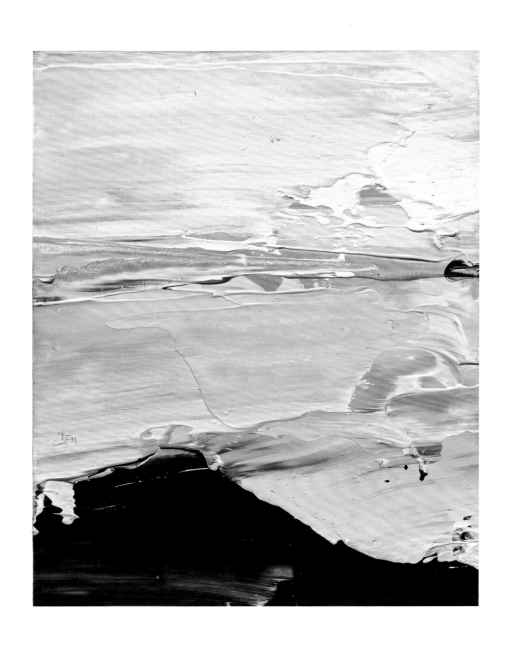

PLATE 24 *Landscape Reflection No. 104, 2007* (cat. 36)

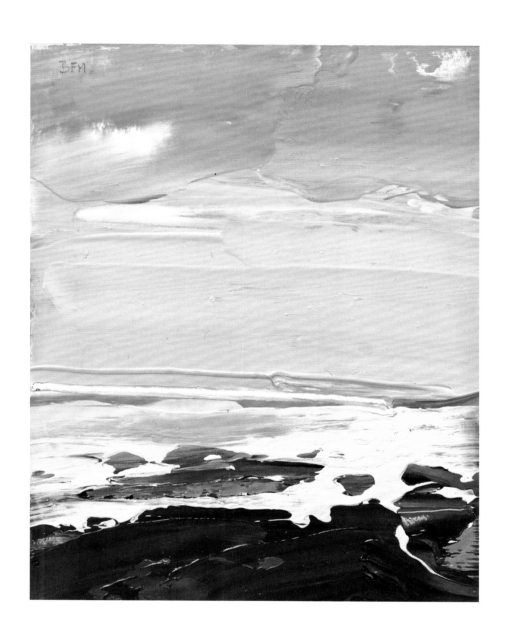

PLATE 25 *Landscape Reflection No. 108, 2007* (cat. 40)

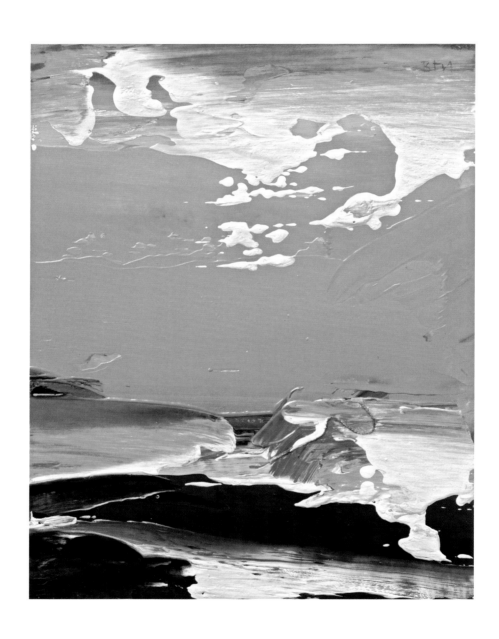

PLATE 26 *Landscape Reflection No. 110, 2007* (cat. 42)

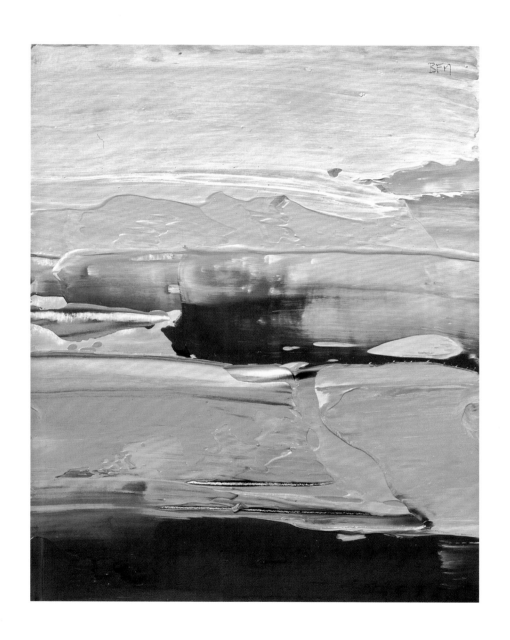

PLATE 27 *Landscape Reflection No. 114, 2007* (cat. 44)

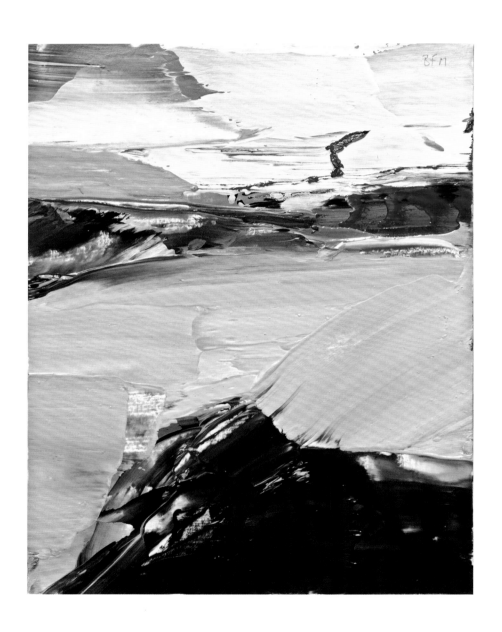

PLATE 28 *Landscape Reflection No. 105, 2007* (cat. 37)

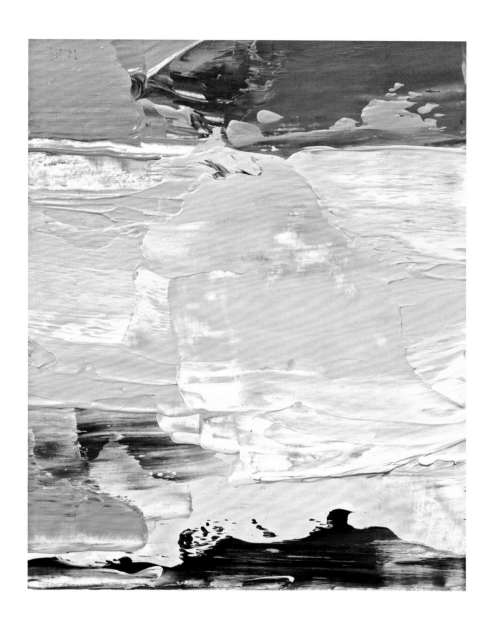

PLATE 29 *Landscape Reflection No. 117, 2007* (cat. 47)

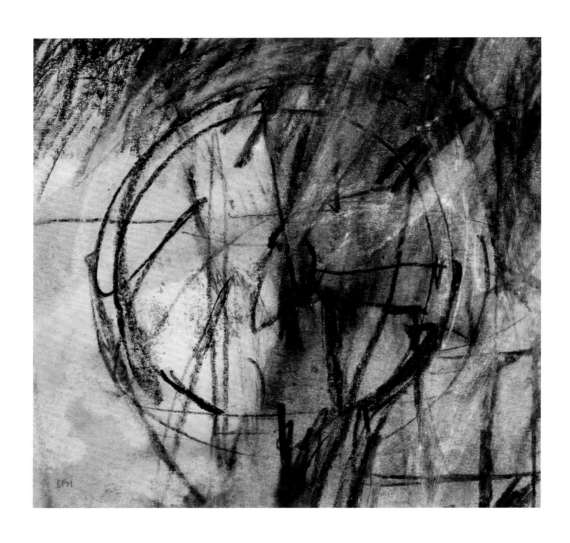

PLATE 38 *Spokane Space—Wheel*, 1964 (cat. 50)

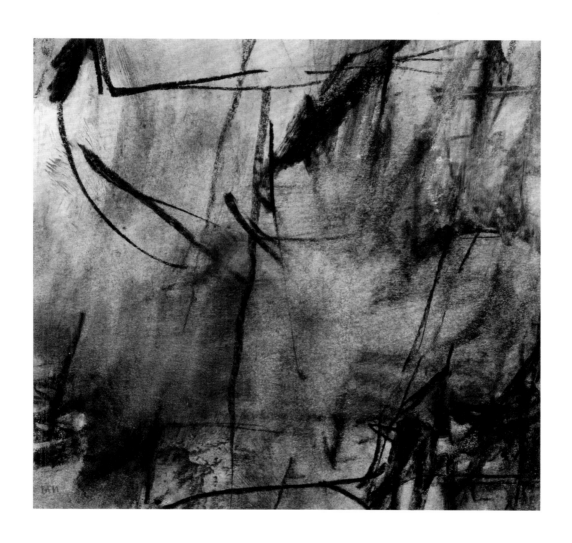

PLATE 31 *Spokane Space No. 4*, 1964 (cat. 51)

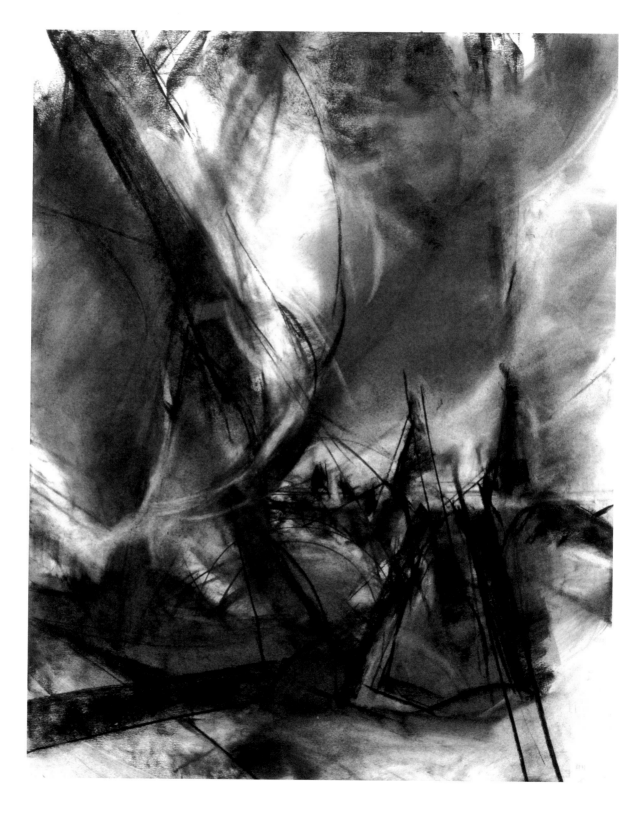

PLATE 32 *Night Sail / Triangle Cross,* 1992 (cat. 52)

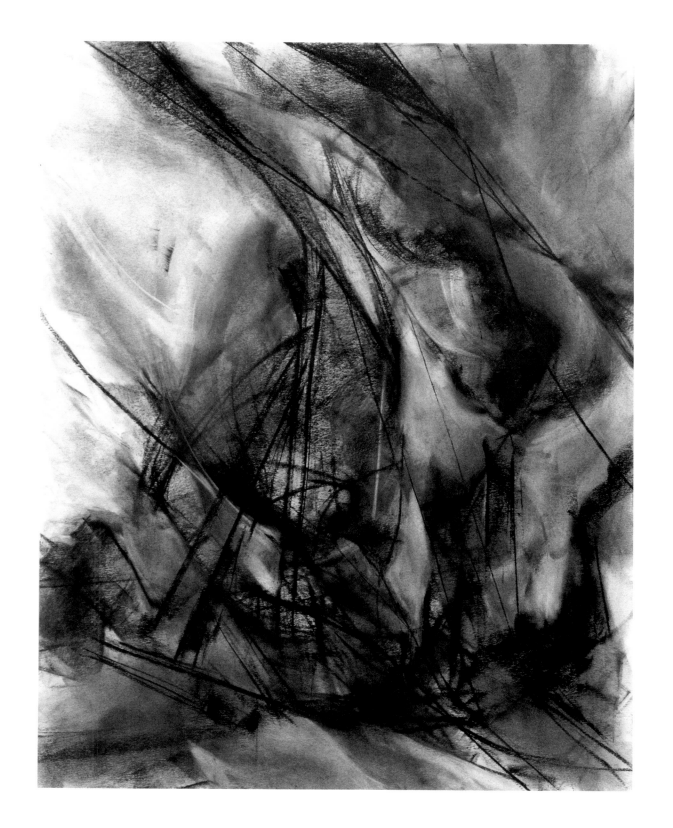

PLATE 33 *Night Sail / Storm No. 1*, 1992 (cat. 53)

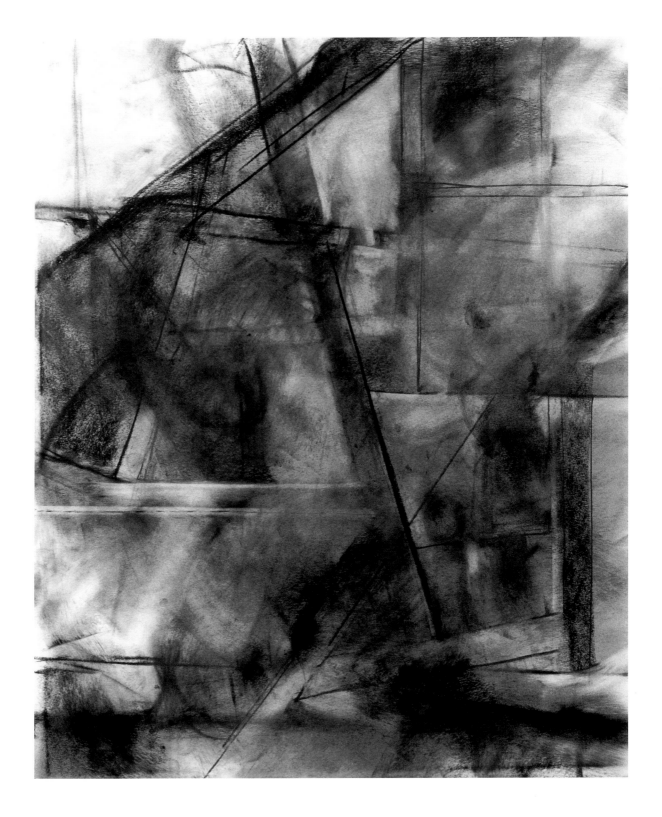

PLATE 34 *Return No. 19, 2003* (cat. 57)

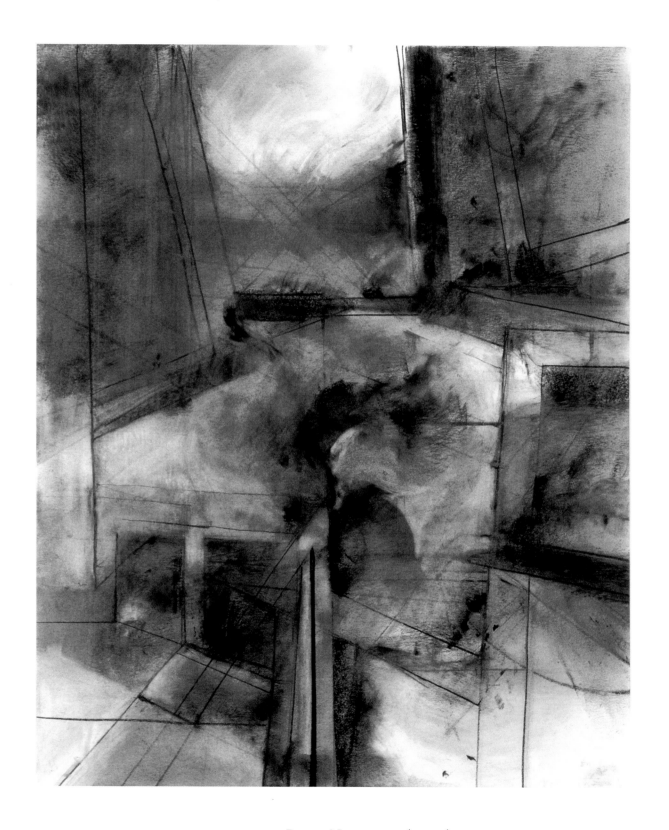

PLATE 35 *Return No. 41, 2003* (cat. 58)

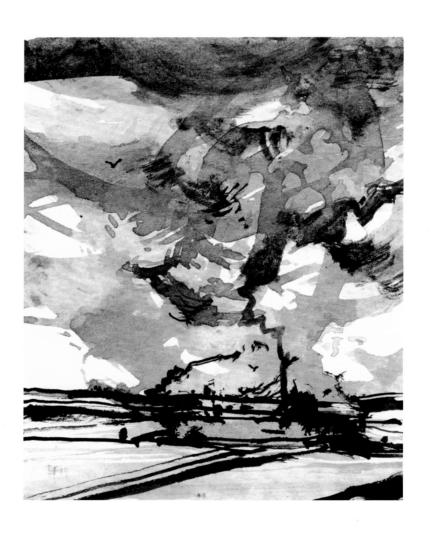

PLATE 36 *Landscape Sound No. 323*, 2004 (cat. 62)

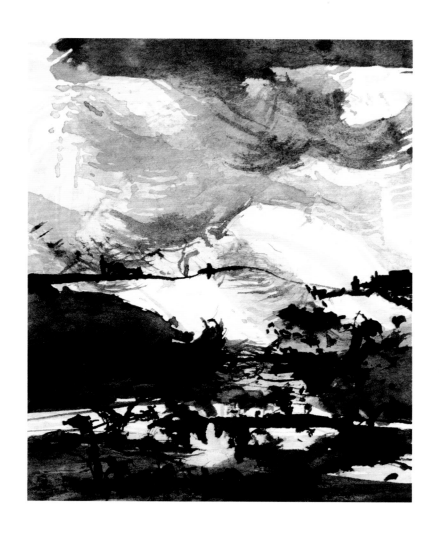

PLATE 37 *Landscape Sound No. 327, 2004* (cat. 63)

84 plate 38 *Boundary No. 8, 2006 (cat. 65)*

PLATE 39 *Boundary No. 15, 2007* (cat. 66)

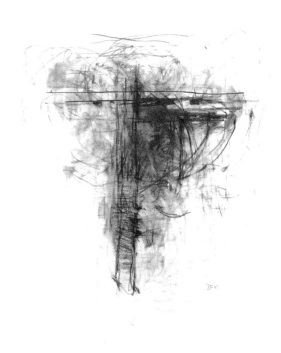

PLATE 40 *Boundary No. 29, 2007* (cat. 67)

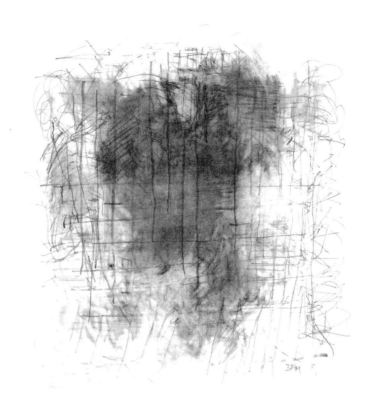

PLATE 41 *Boundary No. 40, 2007* (cat. 68)

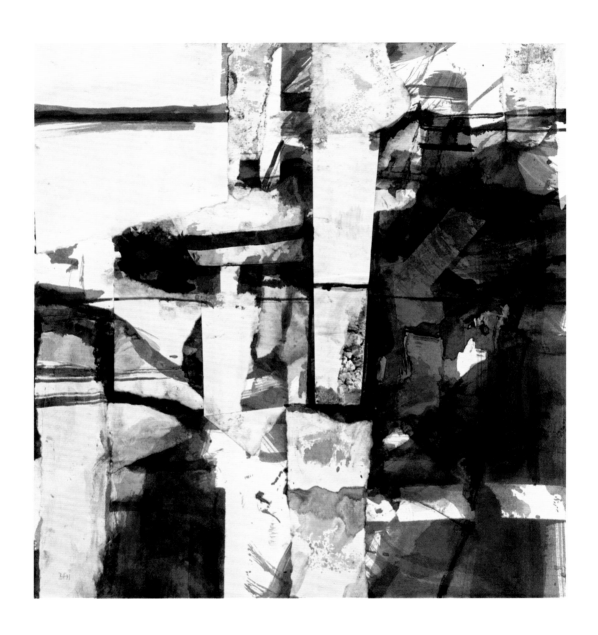

PLATE 42 *Cardinal North No. 5, 2007* (cat. 69)

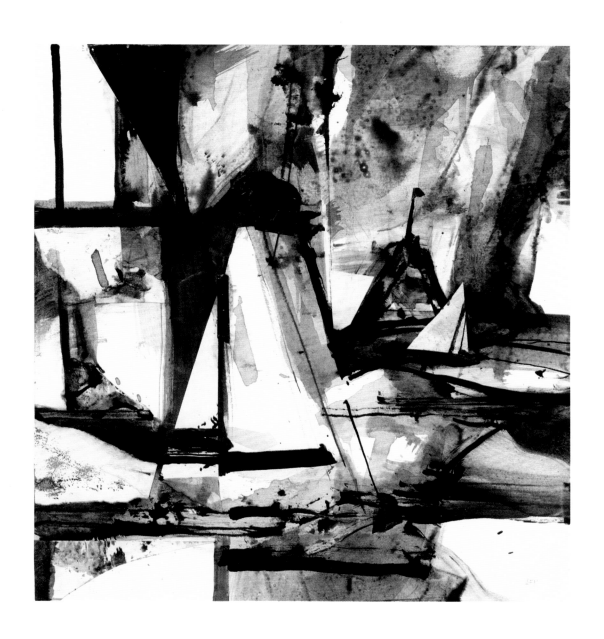

PLATE 43 *Cardinal North No. 26, 2007* (cat. 70)

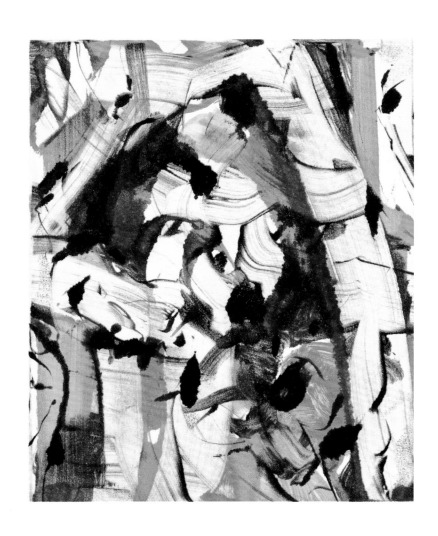

PLATE 44 *Dream Flight No. 42, 2001* (cat. 71)

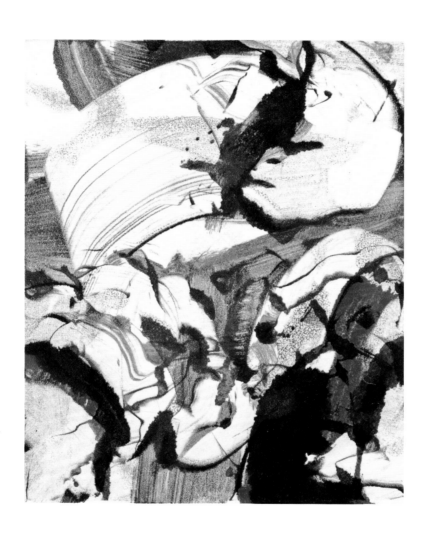

PLATE 45 *Dream Flight No. 152*, 2001 (cat. 73)

Checklist of the Exhibition

Note: Works are listed in approximate chronological order by medium. Dimensions provided are by height, then width. Unless otherwise noted, all works are from the collection of the artist.

PAINTINGS

1 *Box Color Impressions,* 1979
 Oil on paper,
 6 x 6 inches
 Artist No. 1081

2 *Vegetables in Two Bowls,* 1979
 Oil on paper,
 6 x 6 inches
 Artist No. 1088

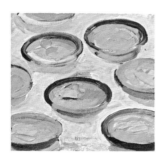

3 *Eight Shallow Dishes,* 1979
 Oil on paper,
 5^{15}/$_{16}$ x 5^{15}/$_{16}$ inches
 Artist No. 1097
 PLATE 1

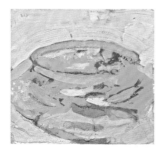

4 *Orange Fish Bowl,* 1979
 Oil on paper,
 5 ⅞ x 6 inches
 Artist No. 1102
 PLATE 3

5 *Grey Fish in Bowl,* 1979
 Oil on paper,
 6⅛ x 6 inches
 Artist No. 1103

6 *Two Boxes with Orange and Blue Ribbon,* 1979
 Oil on paper,
 6⅛ x 6 inches
 Artist No. 1107
 PLATE 2

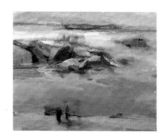

7 *HFM (Helen Figge Moss) Memory,* 1989
 Oil on paper,
 27⅝ x 32 inches
 Artist No. 1774
 PLATE 4

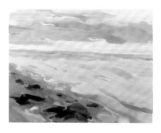

8 *Warmth of Light,* 1989
 Oil on paper,
 27⅝ x 34 inches
 Artist No. 1786
 PLATE 5

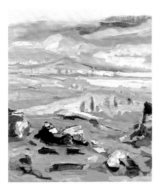

9 *Day Watch No. 1,*
1989
Oil on paper,
34 x 27⅝ inches
Artist No. 1790

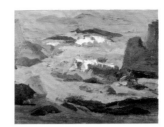

13 *Island Dream /*
Winter, 1991
Oil on paper,
27½ x 34 inches
Artist No. 1871

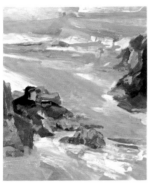

10 *Day Watch No. 2,*
1989
Oil on paper,
34 x 27⅝ inches
Artist No. 1791
PLATE 6

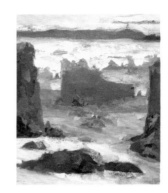

14 *Memory of HFM (Helen*
Figge Moss) No. 2, 1991
Oil on paper,
34 x 27½ inches
Artist No. 1872
National Academy
Museum, New York
PLATE 8

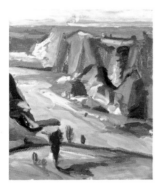

11 *Columbia River*
Dream, 1989
Oil on paper,
34 x 25⅝ inches
Artist No. 1793

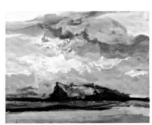

15 *Evening Light /*
Island Dream, 1991
Oil on paper,
27½ x 34 inches
Artist No. 1879

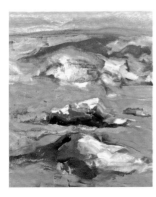

12 *Island Dream No. 4,*
1991
Oil on paper,
34 x 27½ inches
Artist No. 1868
PLATE 7

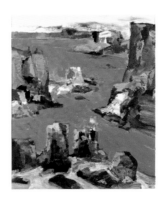

16 *Columbia Summer,* 1991
Oil on paper,
34 x 27½ inches
Artist No. 1882
PLATE 10

17 *Columbia Winter*, 1991
Oil on paper,
27½ x 34 inches
Artist No. 1883
PLATE 9

21 *Passage Remembered
No. 1*, 1994
Oil on paper,
9 x 7⅜ inches
Artist No. 2096
PLATE 12

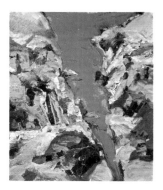

18 *Columbia Dream*, 1991
Oil on paper,
34 x 27½ inches
Artist No. 1884
PLATE 11

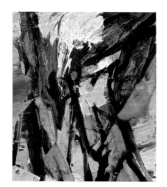

22 *Ascension Fire
No. 4*, 1994
Oil on paper,
9 x 7⅜ inches
Artist No. 2106
PLATE 15

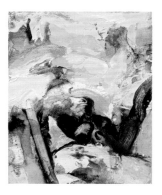

19 *Keeping Watch
No. 1*, 1993
Oil on paper,
9 x 7⅜ inches
Artist No. 1994
PLATE 13

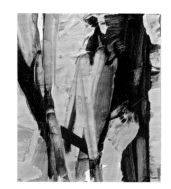

23 *Ascension Fire No. 6*, 1994
Oil on paper,
9 x 7⅜ inches
Artist No. 2111
PLATE 16

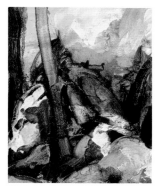

20 *Expectation No. 2*,
1993
Oil on paper,
9¼ x 7⅜ inches
Artist No. 2024
PLATE 14

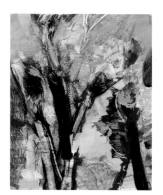

24 *Garden Paradise
No. 19*, 1998
Oil on paper,
9¼ x 7¼ inches
Artist No. 2780
PLATE 17

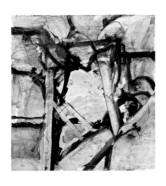

25 *Garden Gateway
No. 6*, 1999
Oil on paper,
11¼ x 10 inches
Artist No. 3043

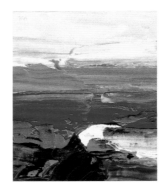

29 *Landscape Sound
No. 144*, 2002
Oil on paper,
6⁹/₁₆ x 5⅜ inches
Artist No. 3602
Memorial Art Gallery
of the University of
Rochester; Marion
Stratton Gould Fund.

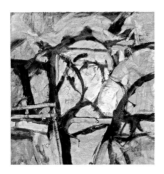

26 *Garden Gateway
No. 9*, 1999
Oil on paper,
11¼ x 10 inches
Artist No. 3049

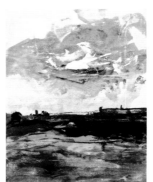

30 *Landscape Reflection
No. 24*, 2005
Acrylic and ink on
paper, 7 x 5⅜ inches
Artist No. 4247

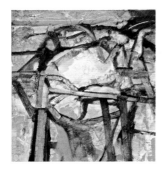

27 *Garden Gateway
No. 11*, 1999
Oil on paper,
11¼ x 10 inches
Artist No. 3052

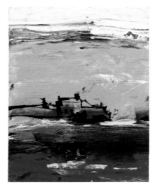

31 *Landscape Reflection
No. 28*, 2005
Acrylic and ink on
paper, 7 x 5⅜ inches
Artist No. 4251

28 *Gateway Tower
Fragment No. 27*, 1999
Oil on paper,
11¼ x 10 inches
Artist No. 3054

32 *Landscape Reflection
No. 74*, 2007
Oil on paper,
8½ x 7⅝ inches
Artist No. 4299

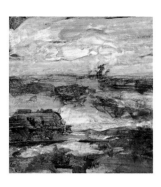

33 *Landscape Reflection*
 No. 75, 2007
 Oil on paper,
 8½ x 7⅝ inches
 Artist No. 4300
 PLATE 22

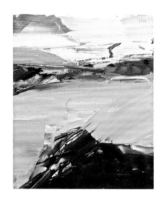

37 *Landscape Reflection*
 No. 105, 2007
 Oil on paper,
 6 x 4¾ inches
 Artist No. 4458
 PLATE 28

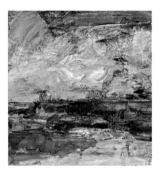

34 *Landscape Reflection*
 No. 76, 2007
 Oil on paper,
 8½ x 7⅝ inches
 Artist No. 4301
 PLATE 23

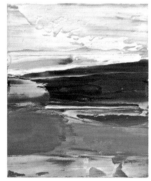

38 *Landscape Reflection*
 No. 106, 2007
 Oil on paper,
 6 x 4¾ inches
 Artist No. 4459

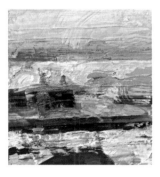

35 *Landscape Reflection*
 No. 99, 2006–7
 Oil on paper,
 8½ x 7⅝ inches
 Artist No. 4482

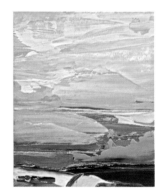

39 *Landscape Reflection*
 No. 107, 2007
 Oil on paper,
 6 x 4¾ inches
 Artist No. 4460

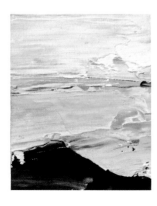

36 *Landscape Reflection*
 No. 104, 2007
 Oil on paper,
 6 x 4¾ inches
 Artist No. 4457
 PLATE 24

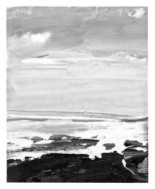

40 *Landscape Reflection*
 No. 108, 2007
 Oil on paper,
 6 x 4¾ inches
 Artist No. 4461
 PLATE 25

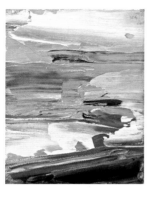

41 *Landscape Reflection
No. 109*, 2007
Oil on paper,
6 x 4¾ inches
Artist No. 4462

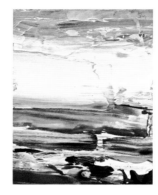

45 *Landscape Reflection
No. 115*, 2007
Oil on paper,
6 x 4¾ inches
Artist No. 4468

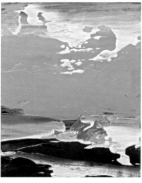

42 *Landscape Reflection
No. 110*, 2007
Oil on paper,
6 x 4¾ inches
Artist No. 4463
PLATE 26

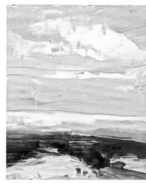

46 *Landscape Reflection
No. 116*, 2007
Oil on paper,
6 x 4¾ inches
Artist No. 4470

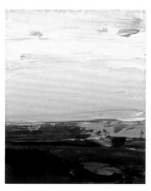

43 *Landscape Reflection
No. 113*, 2007
Oil on paper,
6 x 4¾ inches
Artist No. 4466

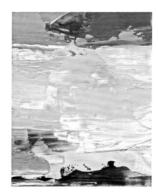

47 *Landscape Reflection
No. 117*, 2007
Oil on paper,
6 x 4¾ inches
Artist No. 4471
PLATE 29

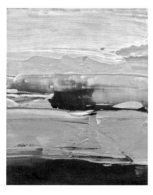

44 *Landscape Reflection
No. 114*, 2007
Oil on paper,
6 x 4¾ inches
Artist No. 4467
PLATE 27

DRAWINGS

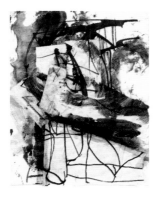

48 *Building No. 3*, 1964
Acrylic, ink, and
charcoal on paper,
11 x 8⅜ inches
Artist No. S/3

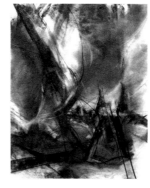

52 *Night Sail / Triangle
Cross*, 1992
Charcoal on paper,
25¼ x 19 inches
Artist No. 1917
Hood Museum of Art:
Purchased through
the Hood Museum
of Art Acquisitions
Fund; D.995.42.1
PLATE 32

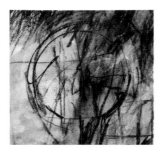

49 *Building No. 4*, 1964
Acrylic, ink, and
charcoal on paper,
11 x 8⅜ inches
Artist No. S/4

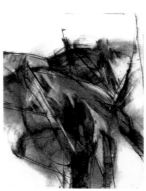

53 *Night Sail / Storm
No. 1*, 1992
Charcoal on paper,
22⅛ x 17 inches
Artist No. 1928B
PLATE 33

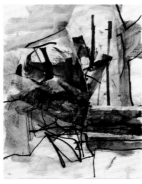

50 *Spokane Space—
Wheel*, 1964
Charcoal and
turpentine on paper,
8⅞ x 9¼ inches
Artist No. S/10
PLATE 30

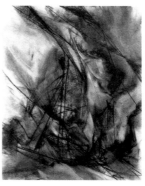

54 *Return Passage /
Thinking of Flight*, 1992
Charcoal on paper,
22⅛ x 17 inches
Artist No. 1944

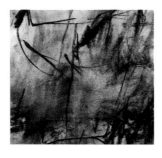

51 *Spokane Space
No. 4*, 1964
Charcoal and
turpentine on paper,
8⅞ x 9¼ inches
Artist No. S/14
PLATE 31

55 *Ship Fire / Aftermath
No. 1*, 1993
Charcoal on paper,
22⅛ x 17 inches
Artist No. 2045

56 *Genesis of Loss /*
Holding the
Course, 1994
Charcoal on paper,
22⅛ x 17 inches
Artist No. 2052

60 *Landscape Sound*
No. 295, 2004
Ink on paper,
5⅜ x 4⁵/₁₆ inches
Artist No. 4003

57 *Return No. 19,* 2003
Charcoal on paper,
22 x 17 inches
Artist No. 3874
PLATE 34

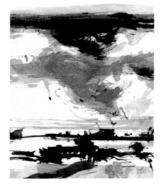

61 *Landscape Sound*
No. 309, 2004
Ink on paper,
5⅜ x 4⁵/₁₆ inches
Artist No. 4017

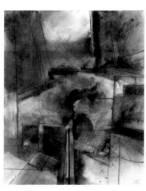

58 *Return No. 41,* 2003
Charcoal on paper,
22 x 17 inches
Artist No. 3896
PLATE 35

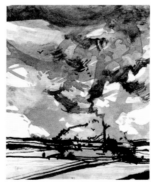

62 *Landscape Sound*
No. 323, 2004
Ink on paper,
5⅜ x 4⁵/₁₆ inches
Artist No. 4031
PLATE 36

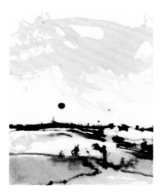

59 *Landscape Sound*
No. 228, 2004
Ink on paper,
5⅜ x 4⁵/₁₆ inches
Artist No. 3936

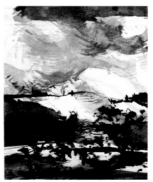

63 *Landscape Sound*
No. 327, 2004
Ink on paper,
5⅜ x 4⁵/₁₆ inches
Artist No. 4035
PLATE 37

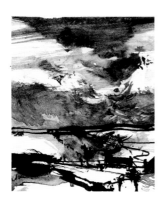

64 *Landscape Sound
No. 340*, 2004
Ink on paper,
5⅜ x 4⁵/₁₆ inches
Artist No. 4048

65 *Boundary No. 8*, 2006
Graphite on paper,
9¾ x 8⅞ inches
Artist No. 4348
PLATE 38

66 *Boundary No. 15*, 2007
Graphite on paper,
9¾ x 8⅞ inches
Artist No. 4355
PLATE 39

67 *Boundary, No. 29*, 2007
Graphite on paper,
9¾ x 8⅞ inches
Artist No. 4369
PLATE 40

68 *Boundary No. 40*, 2007
Graphite on paper,
9¾ 8⅞ inches
Artist No. 4380
PLATE 41

69 *Cardinal North
No. 5*, 2007
Oil, acrylic, and collage
on paper, 12 x 11⅛ inches
Artist No. 4397
PLATE 42

70 *Cardinal North
No. 26*, 2007
Ink, acrylic, and
collage on paper,
12 x 11⅛ inches
Artist No. 4418
PLATE 43

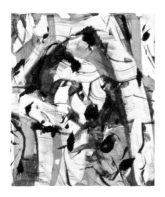

71 *Dream Flight
No. 42, 2001*
Oil monotype on
paper, 5 x 4 inches
Artist No. 3188
PLATE 44

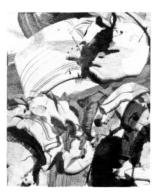

72 *Dream Flight No. 57, 2001*
Oil monotype on
paper, 5 x 4 inches
Artist No. 3203

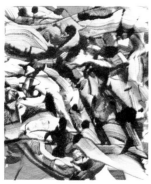

73 *Dream Flight
No. 152, 2001*
Oil on monotype on
paper, 5 x 4 inches
Artist No. 3297
PLATE 45

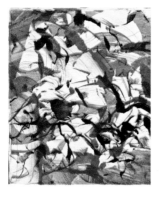

74 *Dream Flight
No. 153, 2001*
Oil monotype on
paper, 5 x 4 inches
Artist No. 3298

Ben Frank Moss: Selected Record

Ben Frank Moss III, N.A.: Born Philadelphia, 1936

Education

The Stony Brook School, Stony Brook, New York, Diploma; Whitworth College, BA; Princeton Theological Seminary; Boston University, MFA (High Honors); Dartmouth College, MA (Honorary)

Major Study with

Walter Murch, Karl Fortess, and Herman Keys

Teaching

George Frederick Jewett Professor of Studio Art, Studio Art Department, Dartmouth College, Hanover, NH, 1993–present / Chautauqua School of Art, Chautauqua, NY, 2001, 2002 / Professor, Department Chair, Studio Art Department, Dartmouth College, Hanover, NH, 1988–1994 / Vermont Studio Center, Johnson, VT, Summer, 1990 / Professor of Painting and Drawing, School of Art and Art History, University of Iowa, Iowa City, IA, 1975–1988 / Acting Dean, Co-Founder of the Spokane Studio School, Spokane, WA, 1972–1974 / Associate Professor, Director of MFA and Visiting Artist Program, Fort Wright College, Spokane, WA, 1965–1972 / Instructor, Gonzaga University, Spokane, WA, 1964–1965

Gallery Representation

Francine Seders Gallery, Ltd., Seattle, 1967–present / La Motta Fine Art, Hartford, CT, 2003–present / Pepper Gallery, Boston, 1997–2008 / Susan Conway Galleries, Washington, DC, 1990–2002 / Kraushaar Galleries, New York, 1978–1999

Solo Exhibitions (Selected)

Hood Museum of Art, Dartmouth College, Hanover, NH, 2008 / Francine Seders Gallery, Ltd., Seattle, 2008, 2005, 1999, 1979 / Cornell College, Mount Vernon, IA, 2007 / Pierce College, Fine Arts Gallery, Fort Steilacoom, Lakewood, WA, 2007 / Trinity College, Hartford, CT, 2006 / Paesaggio Fine Art, Hartford, CT, 2006 / West Chester University, West Chester, PA, 2004 / The Tunbridge Library, Tunbridge, VT, 2004 / New Bedford Art Museum, New Bedford, MA, 2003 / Taylor University, Upland, IN, 2002 / Princeton Theological Seminary, Princeton, NJ, 2001 / Union College, Schenectady, NY, 2000 / Boyer Arts Gallery, Portland, OR, 2000 / Pepper Gallery, Boston, 2000, 1998 / Coe College, Cedar Rapids, IA, 1998 / Ravenscroft School, Raleigh, NC, 1998 / Colorado State University, Fort Collins, CO, 1997 / Gordon College, Wenham, MA, 1996 / Houghton College, Houghton, NY, 1996 / Northwest Missouri State University, Maryville, MO, 1996 / Messiah College, Grantham, PA, 1995 / Loomis Chaffee School, Windsor, CT, 1995 / TASIS England American School, Thorpe, Surrey, England, 1994 / Dartmouth College, Hanover, NH, 1994 / Queens College, University of Melbourne, Melbourne, Australia, 1994 / Susan Conway Galleries, Washington, DC,

1990 / Dartmouth College, Hanover, NH, 1989 / Kraushaar Galleries, Inc., New York, 1987, 1983, 1981 / Columbus Museum of Art, Collector's Gallery, Columbus, OH, 1986 / Swarthmore College, Swarthmore, PA, 1984 / The Stony Brook School, Stony Brook, Long Island, NY, 1982 / Saint-Gaudens National Historic Site, The Picture Gallery, Cornish, NH, 1981 / Kansas State University, Manhattan, KS, 1980 / Hudson D. Walker Gallery, Fine Arts Work Center, Provincetown, MA, 1978 / Arnot Art Museum, Elmira, NY, 1977 / Kirkland College, Clinton, NY, 1977 / Juniper Tree Gallery, Spokane, WA, 1975 / Middlebury College, Middlebury, VT, 1971 / Seligman Gallery, Seattle, 1969, 1967 / Marylhurst College, Portland, OR, 1969 / Cheney Cowels Memorial Museum, Spokane, WA, 1967

Small Group Exhibitions (Two to Five Artists)

"Drawings," Pepper Gallery, Boston, 2006 (with Michael David, Stephen Fisher, Lois Tarlow) / "Selected Works By," Pepper Gallery, Boston, 2005 (with Judith Belzer, Phyllis Berman, Stanley Bielen, Howard Silberthau / 100 Pearl Gallery, Hartford, CT, 2005 (with Joe Byrne) / New England College, Henniker, NH, 2003 (with Joe Byrne) / Art Access Gallery, Bexley, OH, 2002 (with Lucy Barber, Deborah Kirkland, Carmela Kolman) / The Art Spirit Gallery of Fine Art, Coeur d'Alene, ID, 1998 (with Mel McCuddin) / Spheris Gallery of Fine Art, Walpole, NH, 1997 (with Colleen Randall) / Pepper Gallery, Boston, 1997–1998 (with Nancy Friese, David Gloman, Marja Lianko, Eleanor Miller) / Phillips Exeter Academy, The Lamont Gallery, Exeter, NH, 1994 (with Prilla Smith-Brackett and Alice Spencer) / Susan Conway Gallery, Washington, DC, 1993 (with Margaret Olney McBride and Frank Chapin) / Chase Gallery at City Hall, Spokane, WA, 1993 (with Stan Taft and Marilyn Bruya) / Colby-Sawyer College, New London, NH, 1992 (with Blair Folts) / Idaho State University, Pocatello, ID, 1972 (with Wayne Thiebaud and Carol Summers) / Francine Seders Gallery, Seattle, 1972 (with Guy Anderson, Norman Lundin, and Pat Nicholson)

Group Exhibitions (Selected)

Francine Seders Gallery Ltd., Seattle, 1967–1985, 1998–present / Pepper Gallery, Boston, 1997–2008 / La Motta Fine Art, Hartford, CT, 2003–present / Spheris Gallery of Fine Art, Walpole, NH, 1997–2001 / Susan Conway Gallery, Washington, D.C., Santa Fe, NM, 1989–2003 / Grayson Gallery, Woodstock, VT, 2001–2002 / Kraushaar Galleries, Inc., New York, 1978–1999 / "Still Life Today," Bigtown Gallery, Rochester, VT, 2008 / "In/Out," Hobart and William Smith Colleges, Geneva, NY, 2008 / "Small Takes: Zeuxis at First Gallery," New York, 2008 / "Out of the Box: Zeuxis Paints the Landscape," Delaware College of Art and Design, Wilmington, DE, 2008 / "Studio Art Faculty," Jaffe-Friede and Strauss Galleries, Dartmouth College, Hanover, NH, 2008, 2007, 2005, 2003, 2000, 1997, 1993 / "Summer Salon," Pepper Gallery, Boston, 2007 / "On Board," Lori Bookstein Fine Art, New York / "182nd Annual: An Exhibition of Contemporary American Art," National Academy Museum, New York, 2007 / "A Paean to Spring," Paesaggio Fine Art, West Hartford, CT, 2007 / "Sala / Studio Works on Paper," Alva deMars Megan Chapel Art Center, Saint Anselm College, Manchester, NH, 2006 / "Recent Donations and Acquisitions," The Hallie Ford Museum of Art, Willamette University, Salem, OR, 2006 / "Recent Gifts and Acquisitions," Gonzaga University, Spokane, WA, 2006 / "Drawings," Pepper Gallery, Boston, 2006 / "Facets of Perception," Wiegand Gallery, Notre Dame de Namur University, Belmont, CA, 2006; Newhouse Center for Contemporary Art, Snug Harbor Cultural Center, Staten Island, NY, 2006; Schweinfurth Memorial Art Center, Auburn, NY, 2006; "Alumni Invitational & Juried Exhibition," Koehler Gallery, Whitworth College, Spokane, WA, 2006 / "Holiday Salon," Paesaggio Fine Art, Hartford, CT, 2005 / "Form and Presence: Paintings and Drawings from the Collection," Hood Museum of Art, Dartmouth College, Hanover, NH, 2005 / "Picture Planes," Alva deMars Megan Chapel Art Center, St. Anselm College, Manchester, NH, 2005 / 180th Annual Exhibition, National Academy Museum, New York, 2005 / U.S. Artists 14th Annual "American Fine Art Show," 33rd Street Armory, Philadelphia, 2005 / "Black and White," Paesaggio Gallery, West Hartford, CT, 2005 / "Selections," Paesaggio Gallery, West Hartford, CT, 2005 / Fall Group Show, Paesaggio Gallery, West Hartford, CT, 2004 / "Table Top Arenas," Colby College Museum of Art, Waterville, ME; Lori Bookstein Gallery, New York, 2004; The Art Gallery, University of New Hampshire, Durham, NH, 2004; Cantor Fitzgerald Gallery, Haverford College, Haverford, PA, 2005; Ohr-O'Keefe Museum of Art, Biloxi, MS, 2005 / AAF Contemporary Art Fair, Pier 92, New York, 2004 / U.S. Artists 13th Annual "American Fine Art Show," 33rd Street Armory, Philadelphia, 2004 / "Inspired by 6—Recent Acquisitions," Charles H. MacNider Art Museum, Mason City, IA, 2004 / "The Still

Life: The Human Presence," Aquinas College, Grand Rapids, MI, 2004 / "Holiday Salon," Paesaggio Gallery, West Hartford, CT, 2003–2004 / "Small Art Works," Art Spirit Gallery of Fine Art, Coeur d'Alene, ID, 2003 / "Zeuxis at L.I.U.," Salena Gallery, Long Island University, Brooklyn Campus, Brooklyn, NY, 2003 / "Conversations," Evergreen House, John Hopkins University, Baltimore, MD, 2003; Delaware Center for Contemporary Art, Wilmington, Delaware, 2004; Joseloff Gallery, Hartford Art School, University of Hartford, Hartford, CT, 2004; Tufts University Gallery, Medford, MA, 2004; Bevier Gallery, Rochester Institute of Technology, Rochester, NY, 2004; Karl Drerup Gallery, Plymouth State University, Plymouth, NH, 2005–2006 / "A Fine Line: Drawings by National Academicians," National Academy of Design, New York, 2003–2004 / U.S. Artists 12th Annual "American Fine Art Show," 33rd Street Armory, Philadelphia, 2003 / 178th Annual Exhibition, National Academy of Design, New York, 2003 / "Works on Paper," Pennsylvania Academy of the Fine Arts, Philadelphia, 2003 / "A Moveable Feast / Zeuxis," Westbeth Gallery, New York, 2003 / "Winter Salon," Pepper Gallery, Boston, 2003 / "Vermont Studio Center Press: Prints," The Robert Hull Fleming Museum, University of Vermont, Burlington, VT, 2002 / U.S. Artists 11th Annual "American Fine Art Show," 33rd Street Armory, Philadelphia, 2002 / "Americans Explore Landscape," Augustana College, Rock Island, IL, 2002 / "Works of Substance: Works of Faith," Marywood University, Scranton, PA, 2002 / "Uncommon Perspectives," Denise Bibro Fine Art, Inc., New York, 2002; Hermitage Foundation Museum, Norfolk, VA, 2002; Attleboro Museum, Attleboro, MA, 2003; Washington Art Association, Washington Depot, CT, 2003 / Chautauqua Institution School of Art, Chautauqua, NY, 2002 / "Art on Campus," Southern Vermont Arts Center, Manchester, VT, 2002 / "An Evening of Unearthly Delights," DeCordova Museum and Sculpture Park, Lincoln, MA, 2002 / New England College, Henniker, NH, 2002 / Richard Stockton College, Pomona, NJ, 2001 / Rittenhouse Fine Art, Philadelphia, 2001 / New Jersey Center for the Arts, Summit, NJ, 2001 / "Serial Thinking," Wright State University, Dayton, OH, 2001; Kouros Gallery, New York, 2001; Augustana College, Rock Island, IL, 2001; Purdue University, West Lafayette, IN, 2002 / "Abstraction: The Power of Memory," Bethel College, Mishawaka, IN, 2001; Gallery W, Sacramento, CA, 2001; Urban Art Institute, Chattanooga, TN, 2001; Merrick Art Gallery, New Brighton, PA, 2001; Houghton College, Houghton, NY, 2001; John Brown University, Siloam Springs, AR, 2001; Sweetwater Center for the Arts, Sewickley, PA, 2002; Gordon College, Wenham, MA, 2002; Forth Presbyterian Church, Chicago, 2002; Calvary Chapel of Costa Mesa, Santa Ana, CA, 2002; Union University, Jackson, TN, 2002; Indiana Wesleyan University, Marion, IN, 2002; Trinity Christian Institute, Addison, TX, 2003; Marywood University, Scranton, PA, 2003 / "Zeuxis / Still Life," 100 Pearl Gallery, Hartford, CT, 2001 / Chautauqua Institution School of Art, Chautauqua, NY, 2001 / The U.S. Artists 10th Annual "American Art Exposition and Sale," 33rd Street Armory, Philadelphia, 2001 / "Distinct Visions—Diverse Pursuits," The College of William and Mary, Williamsburg, VA, 2001 / The 176th Annual Exhibition, The National Academy of Design, New York, 2001 / "May Group Show," Susan Conway Gallery, Washington, DC, 2001 / "2000 Review," Pepper Gallery, Boston, 2000 / "Holiday 2000, Deck the Walls," Susan Conway Gallery, Washington, DC, 2000 / "Drawing from the Collection," Hood Museum of Art, Dartmouth College, Hanover, NH, 2000 / "Still Life Paintings," The College of William and Mary, Williamsburg, VA, 2000 / "Still Life Paintings," Olson-Larson Galleries, West Des Moines, IA, 2000 / "ARTcetera," Boston Center for the Arts, Boston, 2000 / "Small Landscapes: Seven Views," Auburn Arts Association Gallery, Auburn, AL, 2000 / "Small Landscapes: Seven Views," Eastern Shore Art Center, Fairhope, AL, 2000 / "Selected Gallery Artists," Grayson Gallery, Woodstock, VT, 2000 / "Human Presence," The Painting Center, New York, 2000 / U.S. Artist 2000, "The American Art Exposition and Sale," 33rd Street Armory, Philadelphia, 2000 / "Human Presence," Erector Square Gallery, New Haven, CT, 2000 / "Works on Paper," The Twelfth Annual, The Park Avenue Armory, New York, 2000 / "Human Presence," Courtyard Gallery, Washington Studio School, Washington, DC, 2000 / "Human Presence," Peninsula Fine Arts Center, Newport News, VA, 2000 / "Zeuxis," University Art Galleries, Marywood University, Scranton, PA, 1999 / "Zeuxis," Marymount College, Tarrytown, NY, 1999 / "Human Presence," University Art Gallery, University of Wisconsin–La Crosse, La Crosse, WI, 1999 / Gallery Artists, Pepper Gallery, Boston, 1999 / Third Annual Boston International Fine Art Show, Boston Center for the Arts, Boston, 1999 / "Ecstasy and Silence: Ten Contemporary American Painters," Delaware College of Art and Design, Wilmington, DL, 1999 / U.S. Artists 99, "Exposition and Sale of American Art," 33rd Street Armory, Philadelphia, 1999 / The 174th Annual Exhibition, The National Academy

of Design, New York, 1999 / "Works on Paper," The Eleventh Annual, The Park Avenue Armory, New York, 1999 / "Gallery Selections," Pepper Gallery, Boston, 1998 / Second Annual Boston International Fine Art Show, Boston Center for the Arts, Boston, 1998 / "The Artist as Collector," Messiah College, Grantham, PA, 1998 / "Still Life Visions," Boston University, Boston, 1998 / U.S. Artists 98, "Exposition and Sale of American Art," 33rd Street Armory, Philadelphia, 1998 / "One Thing on Top of Another," Kerygma Gallery, Ridgewood, NJ, 1998 / "Recent Acquisitions: Contemporary Art," Hood Museum of Art, Dartmouth College, Hanover, NH, 1998 / "Works on Paper," The Tenth Annual, The Park Avenue Armory, New York, 1998 / "The Artist Window," Lee Hansley Gallery, Raleigh, NC, 1998 / Art Spirit Gallery, Coeur d'Alene, ID, 1998 / "The Art Show," The Tenth Annual Art Show, The Seventh Regiment Armory, New York, 1998 / "Zeuxis," Erector Square Gallery, New Haven, CT, 1998 / "Object Lessons," Loomis Chaffee School, Windsor, CT, 1997 / U.S. Artists 97, "Exposition of American Art," 33rd Street Armory, Philadelphia, 1997 / The 172nd Annual Exhibition, The National Academy of Design, New York, 1997 / "The Art Show," The Ninth Annual Art Show, The Seventh Regiment Armory, New York, 1997 / Albright-Knox Art Gallery, Members Gallery, Buffalo, N.Y., 1995–1996 / VII+I, Susan Conway Gallery, Washington, DC, 1995–1996 / "Intimate Spaces," Blair Academy, Blairstown, NJ, 1996 / "Drawing Invitational," Smith College, Northampton, MA, 1996 / "Out of the Ordinary," Marymount Manhattan College, New York, 1996 / "The Art Show," The Eighth Annual Art Show, The Seventh Regiment Armory, New York, 1996 / The 170th National Academy of Design Annual, New York, 1995 / "Memento Vida—Reminders of Life," Brattleboro Museum and Art Center, Brattleboro, VT, 1995 / "Collection Update 1995: Recent Acquisitions," National Academy of Design, New York, 1995 / Boston University, "Alumni Drawings," Boston, 1995 / "The Art Show," The Seventh Annual Art Show, The Seventh Regiment Armory, New York, 1995 / "The Artist as Native: Re-Inventing Regionalism," Middlebury College Museum of Art, Middlebury, VT; Babcock Galleries, New York; Albany Institute of History and Art, Albany, NY; Owensboro Museum of Fine Art, Owensboro, KY; Westmoreland Museum of Art, Greenburg, PA; Maryland Institute and College of Art, Baltimore, MD, 1993–1994 / "The Art Show," The Sixth Annual Art Show, The Seventh Regiment Armory, New York, 1994 / J. S. Ames Fine Art, Belfast, ME, 1994 / Gallery Sixty-Eight, Belfast, ME, 1994, 1992 / Vermont Studio Center, Visiting Critics, Vergennes, VT, 1992 / "The Art Show," The Fifth Annual Art Show, The Seventh Regiment Armory, New York, 1993 / "The

Art Show," The Fourth Annual Art Show, The Seventh Regiment Armory, New York , NY, 1992 / 79th Annual Maier Museum of Art, Randolph-Macon Women's College, Lynchburg, VA, 1990 / Delaware Center for the Contemporary Arts, "The Qualities of Paint," Wilmington, DE, 1988 / University of Iowa, Iowa City, IA, 1988, 1986, 1984, 1982, 1980, 1978, 1976 / Blanden Memorial Museum, Fort Dodge, IA, 1987 / Philadelphia Museum of Art, Philadelphia, 1986 / Union League Club, New York, 1986 / "The Artist Interprets the Landscape," Blackfish Gallery, Portland, OR, 1986 / Columbia Museum of Art, Columbia, SC, 1985 / Columbus Museum of Art, Columbus, OH, 1982–1986 / "Midwest Realists," Paine Art Center, Oshkosh, WI, 1985 / Burpee Art Center, Rockford, IL, 1985 / Illinois State University, Normal, IL, 1985 / "The Expressive Landscape," Wilkes College, Wilkes-Barre, PA, 1985 / Albright-Knox Museum, Buffalo, NY, 1984 / Arkansas Art Center, Little Rock, AK, 1984 / Millersville University, Millersville, PA, 1984 / "Realist Directions," Pennsylvania State University, University Park, PA, 1983 / Fairfield University, Fairfield, CT, 1983 / Marion Koogler McKay Institute, San Antonio, TX, 1983 / Montclair Junior League, Montclair, NJ, 1983 / "Iowa Landscapes: Iowa Artists," Augustana College, Rock Island, IL, 1983 / "New Works of Boston University Alumni," Boston City Hall Gallery, Boston, 1983 / "Iowa Artists," Cedar Rapids Museum of Art, Cedar Rapids, IA, 1982 / Montclair Junior League, Montclair, NJ, 1981 / "Small Paintings," Iowa Arts Council (traveled to twelve venues), Des Moines, IA, 1980–1981 / "Iowa Drawing Invitational," Iowa Arts Council (traveled to ten venues), Des Moines, IA, 1980–1981 / Bowery Gallery, New York 1977 / Cheney Cowles Memorial Museum, Spokane, WA, 1975, 1968, 1967, 1966, 1965, 1964 / Stan Taft Gallery, Spokane, WA, 1974 / The Spokane Studio School, Spokane, WA, 1973 / Francine Seders Gallery, Seattle, 1972–1985 / Minot State College, Minot, ND, 1971, 1970 / Wenatchee Valley College, Wenatchee Valley, WA, 1971, 1970, 1968, 1967, 1965, 1964 / University of North Dakota, Grand Forks, ND, 1970, 1968, 1966, 1965, 1963 / Western Washington State University, Bellingham, WA, 1970, 1968 / Boston University, Boston, 1969 / Charles and Emma Frye Art Museum, Seattle, 1969 / State Capital Museum, Olympia, WA, 1969, 1968 / Central Washington University, Ellensburg, WA, 1969 / Washington State University, Pullman, WA, 1969, 1968, 1964 / Seattle Art Museum Pavilion, Seattle, 1968, 1967, 1965 / Northern Illinois University, Dekalb, IL, 1968 / Seattle Pacific College, Seattle, 1968 / Gonzaga University, Spokane, WA, 1968 / Winn

Galleries, Austin, TX, 1968 / Image Gallery, Portland, OR, 1968, 1967 / Bucknell University, Lewisburg, PA, 1967, 1966 / Dickinson State College, Dickinson, ND, 1967 / PM Gallery, Seattle, 1967 / Ball State University, Muncie, IN, 1966 / The Butler Institute of American Art, Youngstown, OH, 1966 / University of Idaho, Moscow, ID, 1965 / Spokane Falls Community College, Spokane, WA, 1965

Grants, Fellowships, Awards, and Honors (Selected)

Annual scholarship established in honor of Ben Frank Moss for entering first-year student, Houghton College, Houghton, NY, 2008 / The Charles Loring Elliot Award and Medal for Drawing, The National Academy Museum, New York, 2007 / Pouch Cove Foundation, St. John's, Newfoundland, Canada, 2002 / Sabbatical, Dartmouth College, Hanover, NH, 2003, 2001, 1996, 1994 / The Virginia Center for the Creative Arts, Mt. San Angelo, Sweet Briar, VA, 1996 / The Millay Colony for the Arts, Steepletop, Austerlitz, NY, 1996 (declined) / The Tyrone Guthrie Center at Annaghmakerrig, Newbliss, Co. Monaghan, Ireland, 1996 (declined) / Honorary MA, Dartmouth College, 1993 / Studio Art Outstanding Teaching and Mentoring Award, Dartmouth College, 2004 / Senior Faculty Fellowship, Dartmouth College, 1993 / The MacDowell Colony, Peterborough, NH, 1991 / Distinguished Alumni Award, Boston University, 1988 / Research Grants, Dartmouth College, 1990–2004 / Developmental Grant, University of Iowa, Iowa City, IA, 1986, 1980 / University of Iowa Foundation Travel Grant, 1986 / Summer Fellowship, University of Iowa, 1979 / Ford Foundation Research and Travel Grant, 1979–80 / Yaddo Foundation, Saratoga Springs, NY, 1972, 1965 / Purchase Award, University of South Dakota, Grand Forks, ND, 1970 / Cash Award, Wenatchee Valley College, Wenatchee, WA, 1967 / Purchase Award, Western Washington University, Bellingham, WA, 1968 / Finalist Tiffany Foundation, 1966 / Fulbright Hays Recipient (declined), 1966 / Finalist, American Academy in Rome, 1965 / Purchase Award, Western Washington University, Bellingham, WA, 1965

Collections

American University, Watkins Collection, Washington, DC / Alva deMars Chapel Art Center, Saint Anselm College, Manchester, NH / The Art Institute of Chicago / Augustana College Art Gallery and Museum, Rock Island, IL / Boston University School of Art, Boston / Fine Art Center Galleries, Bowling Green State University, Bowling Green, OH / Brooklyn Museum of Art, Brooklyn, NY / Cedar Rapids Museum of Art, Cedar Rapids, IA / Coe College, Cedar Rapids, IA / Corr Cronin, Mishelson Baum Gardner & Preece, L.L.P., Seattle / Peter Paul Luce Gallery, Cornell College, Mount Vernon, IA / DeCordova Museum and Sculpture Park, Lincoln, MA / Hood Museum of Art, Dartmouth College, Hanover, NH / Federal Reserve Bank of Boston / Fort Wright College, Spokane, WA / Jundt Art Museum, Gonzaga University, Spokane, WA / Gordon College, Wenham, MA / Faulconer Gallery, Grinnell College, Grinnell, IA / Houghton College, Houghton, NY / The Hyde Collection, Glen Falls, NY / The University of Iowa Museum of Art, Iowa City, IA / Lukins, Annis, Bastine, McKay & Van Marter, L.L.P., Spokane, WA / Charles H. MacNider Art Museum, Mason City, IA / Messiah College, Grantham, PA / Mundt MacGregor, L.L.P., Seattle / Museum of Art and Culture, Spokane, WA / Museum of Fine Arts, Boston / Museum of Modern Art, New York / National Academy Museum, New York / New Britain Museum of American Art, New Britain, CT / Art Gallery of Newfoundland and Labrador, St. John's, Newfoundland, Canada / University of North Dakota, Grand Forks, ND / Ravenscroft School, Raleigh, NC / REM Capital Corporation, Ontario, Canada / Memorial Art Gallery, University of Rochester, Rochester, NY / Frank Russell Company, Tacoma, WA, New York / Seattle Pacific University, Seattle / Smithsonian American Art Museum, Washington, DC / The Stony Brook School, Stony Brook, NY / Everson Museum of Art, Syracuse University, Syracuse, NY / Tacoma Art Museum, Tacoma, WA / Taylor University, Upland, IN / Pouch Cove Foundation, St. John's, Newfoundland, Canada / Union College, Schenectady, NY / Western Washington University, Bellingham, WA / Hallie Ford Museum of Art, Willamette University, Salem, OR / Whitworth College, Spokane, WA / Yale University Art Gallery, New Haven, CT / Hall ZanZig, L.L.P., Seattle / private collections (over 375)

Membership

Academician Member, National Academy, New York, 1994–present / Who's Who in American Education, 1994–present / Who's Who in America, 1997–present / Who's Who in the East, 1999–present / Who's Who in American Art, 2006–present

Artist in Residence

Vermont Studio School Press, Johnson, VT, 2001 / TASIS The American School in England, Thorpe, Surrey, England, 1994 / Queens College, University of Melbourne, Melbourne, Australia, 1993–1994

Visiting Artist and/or Lecture Invitations (Selected)

Francine Seders Gallery, Seattle, 2008 / Houghton College, Houghton, NY, 2008 / Cornell College, Mount Vernon, IA, 2007 / Trinity College, Hartford, CT, 2006 / Southern Vermont Arts Center, Manchester, VT, 2006 / Whitworth College, Spokane, WA, 2006 / Hood Museum of Art, Dartmouth College, Hanover, NH, 2005 / Messiah College, Grantham, PA, 2005, 1995 / West Chester University, West Chester, PA, 2004 / Delaware College of Art and Design, Wilmington, DE, 2004, 2000, 1999 / University of New Hampshire, Durham, NH, 2004 / University of Washington, Seattle, 2003 / Whitworth College, Spokane, WA, 2003 / New Bedford Art Museum, New Bedford, MA, 2003 / Williams College, Williamstown, MA, 2003 / Bowling Green State University, Bowling Green, OH, 2003 / New England College, Henniker, NH, 2003 / Seattle Pacific University, Seattle, 2002 / Augustana College, Rock Island, IL, 2002 / Visual Artists of Newfoundland and Labrador, Art Gallery of Newfoundland and Labrador, Memorial University of Newfoundland, St. John's, Newfoundland, Canada, 2002 / Chautauqua Institution School of Art, Chautauqua, NY, 2002, 2001 / Taylor University, Upland, IN, 2002 / Princeton Theological Seminary, Princeton, NJ, 2001 / Union College, Schenectady, NY, 2000 / Coe College, Cedar Rapids, IA, 1998 / Ravenscroft School, Raleigh, NC, 1998 / Colorado State University, Fort Collins, CO, 1997 / Northwestern University, Evanston, IL, 1997 / Gordon College, Wenham, MA, 2002, 1996 / Houghton College, Houghton, NY, 2001, 1996 / Northwest Missouri State University, Maryville, MO, 1996 / Swarthmore College, Swarthmore, PA, 1995, 1984 / Messiah College, Grantham, PA, 1995 / Smith College, Northampton, MA, 1995 / Brown University, Providence, RI, 1995 / Middlebury College, Middlebury, VT, 1995 / Trinity College, Hartford, CT, 1995 / Loomis Chaffee School, Windsor, CT, 1995 / Phillips Exeter Academy, Exeter, NH, 1994 / Eton College, Eton, Windsor, England, 1994 / TASIS The American School in England, Thorpe, Surrey, England, 1994 / University of California at Berkeley, 1994 / University of California at Santa Cruz, 1994 / California College of Arts and Crafts, Oakland, CA,

1994 / Dartmouth College, Hanover, NH, 1994 / Colby-Sawyer College, New London, NH, 1992 / Marlboro College, Marlboro, NH, 1992 / Vermont Studio School, Johnson, VT, 1991, 1989, 1988 / Carleton College, Northfield, MN, 1990 / American University, Washington, DC, 1990, 1987 / Boston University, 1989, 1981 / Amherst College, Amherst, MA, 1989 / Auburn University, Auburn, AL, 1989 / University of Southwestern Louisiana, Lafayette, Louisiana, 1989 / Delaware Center for the Contemporary Arts, Wilmington, DE, 1988 / Drexel University, Philadelphia, 1988 / University of Delaware, Newark, DE, 1988 / Dartmouth College, Hanover, NH, 1987 / The Portledge School, Locust Valley, NY, 1987 / Union College, Schenectady, NY, 1987 / Washington University, St. Louis, MO, 1985 / Pennsylvania State University, State Park, PA, 1985 / University of Maine, Machias, ME, 1985 / Vassar College, Poughkeepsie, NY, 1984, 1979 / The Stony Brook School, Stony Brook, NY, 1984, 1982, 1977 / Queens College, New York City University, Flushing, NY, 1982 / University of Washington, Seattle, 1982 / University of Oregon, Eugene, OR, 1982 / Marymount Manhattan College, NY, 1982 / Kansas State University, Manhattan, KS, 1980 / State University of New York at Purchase, 1979 / Provincetown Fine Arts Work Center, Provincetown, MA, 1978 / Yale University, New Haven, CT, 1977 / Augustana College, Rock Island, IL, 1977 / University of Iowa, Iowa City, IA, 1975–1976 / University of Texas, Austin, TX, 1973 / Central Washington State University, Ellensburg, WA, 1972 / Marylhurst College, Portland, OR, 1969

Publications

Note: Within each category, publications are listed chronologically, beginning with the most recent.

Studies

Moss, Ben Frank. "Turning towards the Light," "AfterWord: Whitworth Alumni in Their Own Words." *Whitworth Today* (Spring 2006): 30.

Moss, Ben Frank. "The Empty Chair" for "Bringing Home the Work: The Artist and the Community." In *IMAGE: Art, Faith, Mystery* 38 (Spring 2003): 45–48 (photo, back cover).

"Abstract Art and Concrete Faith: Alumni Donate Painting by Ben Frank Moss." *Seattle Pacific University Magazine* 26, no. 1 (Winter 2003).

Shearon, Diane M. "Memory as Connection: Spirituality and Landscape Painting." Bowling Green State University, December 2002 (typescript).

Moss, Ben Frank. "The Gift's Embrace." *IMAGE: A Journal of the Arts and Religion* 12 (Winter 1995–96): 23–35 (photos).

Gusso, Alan. *Artist as Native: Reinventing Regionalism.* San Francisco: Pomegranate Art Books, 1993, p. 22–23 (artist statement, photo).

Mareneck, Susan. "Ben Frank Moss, Painter." *Kansas Quarterly* 14 (Fall 1982): 43–53 (photos).

Catalogues

Ben Frank Moss: Beyond the Subject, Landscapes, Past and Present, Paintings and Drawings. February 22–March 30, 2008. Francine Seders Gallery, Seattle, 2008. Essay: "Beyond the Subject: Approaching the Vision of Ben Frank Moss," by Michael Stone-Richards. Essay: "A Lifetime of Making Notes of a Lifetime," by Michael Spafford.

182nd Annual Exhibition of Contemporary American Art. National Academy Museum. May 16–June 24, 2007.

Zeuxis: An Association of Still Life Painters. "Facets of Perception." Paintings, traveling, January 25, 2006–September 28, 2007. Essay: "A Glass Seen and Seen-Through," by Martica Sawin.

Disegno: The 180th Annual Exhibition. National Academy Museum. May 2005. Essay: "*Disegno*" by Nancy Malloy.

Zeuxis: An Association of Still Life Painters. "Tabletop Arenas." Paintings, traveling, March 28, 2004–September 10, 2005. Introduction by Joseph Byrne. Essay: "Tabletop Arenas," by Thomas M. Disch.

Conversations: Influence and Collaboration in Contemporary Art. Exhibition at Evergreen House, John Hopkins University, October 9, 2003–January 4, 2004. Preface by Jackie O'Regan. Essay: "Curator's Statement," by Barry Nemett.

178th Annual Exhibition. National Academy of Design, May 2–June 15, 2003.

Zeuxis: An Association of Still Life Painters. "Serial Thinking." Paintings, traveling, April 1 2001–March 10, 2002. Introduction by Phyllis Floyd. Essay: "Still Life Now," by Lance Esplund.

176th Annual Exhibition. National Academy of Design, May 22–June 24, 2001.

Ben Frank Moss, Visionary Enchantments. March 3–April 1, 2000. Pepper Gallery, Boston. Essay: "Journey without End: The Visionary Enchantments of Ben Frank Moss," by Joe Byrne.

Zeuxis: An Association of Still Life Painters. "The Human Presence." Paintings, traveling, September 9–June 17, 2000. Essay: "On Still Life," by Andrew Forge.

Zeuxis: An Association of Still Life Painters. "Zeuxis at Marywood." Paintings, October 31–November 21, 1999. Curated by Mark Webber. Acknowledgments by Sandra Ward Povse. Essay by Mark Webber.

174th Annual Exhibition. National Academy of Design, March 17–April 25, 1999.

172nd Annual Exhibition. National Academy of Design, May 28–June 22, 1997.

170th Annual Exhibition. National Academy of Design, February–April 1995. Essay: "Historical Perspective: The Founding of the Academy."

Ben Frank Moss: A Vision of Passage, Paintings and Drawings. April 5–May 8, 1994. Essay: "Inevitable Transformations: Recent work by Ben Frank Moss," by Clare Rossini. Poem: "In Mammal Hall," by Jennifer Kathleen Moss. Jaffe-Friede & Strauss Galleries, Hopkins Center, Dartmouth College, Hanover, NH.

Ben Frank Moss, Paintings and Drawings. February 4–March 11, 1989. Essay: "Loss and Longing," by Jeff Friedman. Essay: "Celebrations of Memory," by Randall Exon. Introduction: "A First Memory," by Ben Frank Moss. Jaffe-Friede and Strauss Galleries, Hopkins Center, Dartmouth College, Hanover, NH.

The University of Iowa Faculty Art Exhibition 1987. Blanden Memorial Art Museum, Fort Dodge, IA, March 15–April 19, 1987.

The 1988 University of Iowa Faculty Exhibition. The University of Iowa Museum of Art, Iowa City, IA, March 12–May 15, 1988.

Faculty Exhibition 1986. The University of Iowa Museum of Art, Iowa City, IA, January 31–March 16, 1986.

1984 Faculty Exhibition. The University of Iowa Museum of Art, Iowa City, IA, January 28–March 18, 1984.

Faculty Exhibition 1982. The University of Iowa Museum of Art, Iowa City, IA, February 11–March 21, 1982.

Faculty Exhibition 1980. The University of Iowa Museum of Art, Iowa City, IA, April 3–June 22, 1980.

Iowa Arts Council. *Small Paintings*. State Capital Building, Des Moines, IA, 1980.

The Second Iowa Drawing Invitational Exhibition. Blanden Memorial Art Gallery, Fort Dodge, IA, May 11–June 8, 1980.

B. Frank Moss III: An Exhibition of Works Presented by Francine Seders. Seligman Gallery, Seattle, October 3–22, 1969. Statement by Rosemarie Beck.

Cover Art

Cover illustration: *N.W. Landscape Dream No. 108*, oil on paper, 4 x 5 inches, for *Anvil: A Journal of Secondary School Christian Scholarship* 3, no. 1 (Winter 2000).

Cover illustration: *Transformation No. 1 / Changing Sounds*, oil on paper, 9¼ x 7⅛ inches, for *Here in Hanover* 2, no. 3 (Fall 1999).

Jacket Illustration: *Paradise East*, 1986, oil on canvas, 47 x 59 inches, for *Wherever That Great Heart May Be: Stories*, by W.D. Wetherell, University Press of New England, 1996.

Periodical Reviews / Listings

Antiques and the Arts Weekly, New York. "A Fine Line: Drawings by National Academicians," October 3, 2003.

Antiques and the Arts Weekly. "Pepper Gallery Exhibits Works by Ben Frank Moss," March 17, 2000 (photo).

Antiques and the Arts Weekly. "Ben Frank Moss, Drawings and Paintings at Pepper," June 12, 1998 (photo).

American Artist. Alan Gusso, December 1993 (photo).

Arts. Clare M. Rossini, March 1984 (photo).

Forum: Kansas City Artists Coalition. Charles Stroh, December 1980 (photo).

Online Reviews

The Tripod, Arts Articles (trinitytripod.com), Trinity College, Hartford, CT. "Widener Gallery Displays Abstract Art," by Sara Yoo.

Newspaper Reviews

Urban Tulsa Weekly. "The Arts Tsunami," by Holly Wall. August 22, 2007.

New York Times. Art and Design. "182nd Annual, In the 21st Century, the Persistence of Tradition," by Martha Schwendener. June 1, 2007.

The Phoenix. Art and Books, Boston. "Everyday Magic," "Drawing Takes Flight at the Pepper Gallery," by Christopher Millis. February 18, 2006 (photo).

Boston Globe. Arts and Reviews, Drawings. "Witty Drawings," by Cate McQuaid. January 2006.

Philadelphia Inquirer. The Arts and Things to Do. "West Chester University," by Victoria Donohoe. December 5, 2004.

New York Times. "Does Drawing Still Matter? A Show that Suggests Some Answers," by Ken Johnson. October 10, 2003.

The Standard-Times, New Bedford, MA. "A Painter's Painter," by David B. Boyce. June 18, 2003.

The Columbus Dispatch, Columbus, OH. Visual Arts. "Tasty Sample of Fruits of Labor," by Jacqueline Hall. November 2002.

The Times, Beaver Newspapers, Inc., PA. Review by Debra Utterback. January 25, 2002.

Princeton Packet, Princeton, NJ. "Hold the Lost Moment," by Susan Van Dongen. September 21, 2001 (photo).

Auburn News, Auburn, AL. Time Out. "Landscapes: Individual Visions," by Brett Buckmer. September 2000 (photo).

Boston Globe. "Glazed Images Enrich Canvas," by Cate McQuaid. March 23, 2000 (photo).

New York Observer. "Currently Hanging: A Support Group for Painters," by Mario Naves. June 2000.

The Gazette, Cedar Rapids, IA. Arts. "Artist Ben Frank Moss at Coe," October 18, 1998 (photo).

Boston Globe. "Driven to Abstraction by Ben Frank Moss," Cate McQuaid. June 11, 1998 (photo).

Hartford Courant, Hartford, CT. "'Object Lessons,' via Zeuxis," by Amy Ellis. October 1997.

Washington Post. Review by Ferdinand Protzman. January 13, 1996.

Northwest This Week, Northwest Missouri State University, Maryville, MO. January 4, 1995.

The Swinging Bridge, Messiah College: Grantham, PA. Review by Betsy Yoder. November 10, 1995.

Journal Inquirer, Manchester, CT. Review by Steve Starger. February 17, 1995 (photo).

The Oregonian, Portland, OR. Review by Barry Johnson. August 14, 1986.

Times Leader, Wilkes-Barre, PA. Review by Roy Morgan. May 1985.

Quad-City Times, Davenport, IA. Review by Mark Stegmaler. September 11, 1985.

The Argus, Rock Island, IL. Review by Julie Jensen. September 11, 1985.

Des Moines Register. Review by Eliot Nusbaum, February 26, 1984. Review by Nick Baldwin, April 27, 1980. Review by Nick Baldwin, March 12, 1978.

Daily Iowan: Iowa City, IA. Review by Suzanne Richerson, February 8, 1984. Review by Suzanne Richerson, February, 1982. Review by Judith Green, June 11, 1980 (photo).

Spokane Daily Chronicle: July 24, 1967, September 21, 1967, October 15, 1969.

The Spokesman Review. Review by Allegra Berrian, January 27, 1974. Review by Gladys E. Guilbert, November 28, 1971, November 16, 1969, October 5, 1969 (photo), March 23, 1969, February 11, 1968, October 20, 1968, October 1, 1967, April 24, 1966 (photo), December 26, 1965 (photo), May 31, 1964 (photo).

Seattle Times. Review by John Voorhees. October 10, 1969.

Denver Post: "The Life of an Artist," by Eva Hodges, 1961 (photo).

Tape

Archives of American Art. Tapes of Leading American Painters, Sculptors, and Graphic Artists. Smithsonian and Boston University Mugar Memorial Library.

Public Television Interview

New Hampshire Public Television, *New Hampshire Outlook*, with Celene Ramaden, "Metaphorical Lands," New England College Gallery, February 3–March 1, 2003. Aired February 19, 2003, 10:00 PM, and February 20, 2003, 1:00 AM, 6:30 AM.

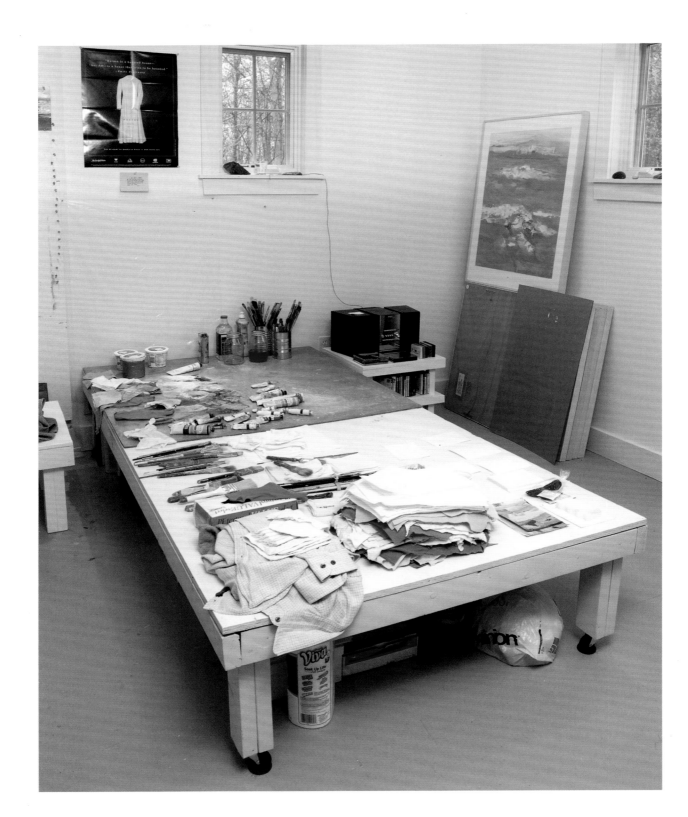